POSTCARD HISTORY SERIES

Fredericksburg

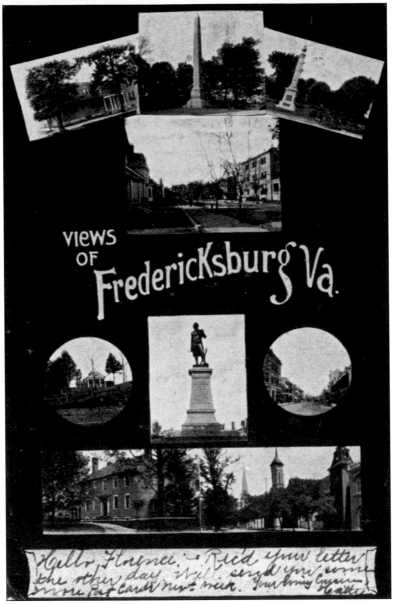

MULTI-VIEW OF WELCOME TO FREDERICKSBURG. This *c.* 1906 postcard shows, from left to right and top to bottom, the Mary Washington House, the Mary Washington Monument, the entrance to the National Cemetery, Hanover Street, Brompton, Hugh Mercer Statue, Caroline Street, Kenmore, and Princess Anne Street.

ON THE FRONT COVER: D. Letcher Stoner created a general store museum located at 1202 Prince Edward Street, called Stoner's Store. This was typical of a 19th-century general store. Stoner exhibited over 13,000 pieces of authentic Americana of the 1800s that he collected over 50 years. Ninety percent of the exhibit came from within 50 miles of Fredericksburg.
ON THE BACK COVER: Caroline Street was the main street of Fredericksburg during the Colonial period. The colonists would suffer great shock to see the street shown in this postcard paved, with electric poles and 1950s cars and clothing.

POSTCARD HISTORY SERIES

Fredericksburg

De'Onne C. Scott

ARCADIA
PUBLISHING

Published by Arcadia Publishing
Charleston SC, Chicago IL, Portsmouth NH, San Francisco CA

Printed in the United States of America

Library of Congress Catalog Card Number: 2006932236

For all general information contact Arcadia Publishing at:
Telephone 843-853-2070
Fax 843-853-0044
E-mail sales@arcadiapublishing.com
For customer service and orders:
Toll-Free 1-888-313-2665

Visit us on the Internet at www.arcadiapublishing.com

CONTENTS

Acknowledgments

I give my thanks to all authors and organizations that have recorded the history and images of the Fredericksburg area, including Edward Alvey Jr., Virginia Carmichael, Alvin T. Embrey, John T. Goolrick, Historic Fredericksburg Foundation, Lemuel W. Houston, S. J. Quinn, Ronald E. Shibley, Barbara Pratt Willis, Paula S. Felder, and the *Free Lance-Star Newspaper*. Without the work of these, my book could not have been written in the time allotted.

Bill Beck of Beck's Antiques deserves thanks for the loan of postcards from his collection. Once again, I offer my gratitude to David Berreth, director, and Joanna Catron, curator, of the Gari Melchers Home and Studio, University of Mary Washington for allowing me to include postcard images from their archives.

Even more than my previous book, my husband, Paul, who helped me complete this book with writing and researching, deserves my greatest thanks. He has always been my best compass, and I could not have written this book without his help. I also thank our daughter, Cary, who gave me help that can never be erased. And thanks must be given to Jerry Cox, who so graciously and expertly proofed this work.

AUTHOR'S NOTE: The postcards in this book are generally listed alphabetically by subject within each chapter. The postcards contained in this book are from my collection unless stated otherwise. Postcards that have a place for a one-line message on the front picture side are the oldest, dating from *c.* 1903.

INTRODUCTION

Fredericksburg's history includes some of the most important people and events in American history. From John Smith to George Washington and James Monroe, and from fighting the Mannahoack Indians to fighting the American Revolution and the Civil War, Fredericksburg helped shape the course of American history.

Fredericksburg's history as we know it began in 1608 when Capt. John Smith encountered a group of Mannahoack Indians who lived along the Rappahannock River, which divides present-day Fredericksburg from Stafford County. The Mannahoacks shot arrows at Smith and his party during their exploration by barge to the fall line of the Rappahannock River. The encounter led to the capture of an injured Native American, which offered a chance for communication with the natives of the area. The Rappahannock River was an important source of food and transportation to the settlers who followed Smith to the area and continues to provide fishing and recreation today.

Fredericksburg was laid out east of the fall line along the Rappahannock River in 1671 on 50 acres of the original 2,000-acre Buckner-Royston land patent granted by Gov. William Berkeley to serve as a frontier river port. The General Assembly established Fredericksburg in 1728 and named it for Prince Frederick, son of King George III. The streets in the original town are still in place and bear their original names honoring Frederick's family—Sophia, Caroline, Princess Anne, Charlotte, George, Hanover, William, and Amelia. The streets in the 1759 addition to the town retain their original names as well.

Fredericksburg became an official receiving and inspection station for tobacco. Pioneer planters and homesteaders needed a port to ship their tobacco and other crops. This helped make Fredericksburg a prosperous port town. It was designated the new site of the county court by 1732.

In 1738, George Washington's family arrived at their new home, called Ferry Farm, located in Stafford County across the Rappahannock River from Fredericksburg. This was just as Fredericksburg's frontier period was ending. At the time, Fredericksburg had almost as many taverns as warehouses. The Washington family had an influence on Fredericksburg's history. Augustine Washington, George's father, was trustee of Fredericksburg by 1749. George surveyed Kenmore for his sister, Betty, and her fiancé, Fielding Lewis, in February 1752. The home George's brother, Charles, built is now the Rising Sun Tavern. George's mother, Mary Ball Washington, lived in Fredericksburg until her death in 1789.

Washington was the most famous of the many important men who have been associated with Fredericksburg. Other notables include Adm. John Paul Jones, Marquis de Lafayette, Gen. Hugh

Mercer, James Monroe, and Matthew Fontaine Maury. The first resolution declaring American independence passed in Fredericksburg. In 1775, Col. Fielding Lewis and Charles Dick established the gunnery in Fredericksburg to help supply the Americans with arms to fight the revolution. The Statute of Religious Liberty was written in Fredericksburg in 1781. Later that year, Dr. Charles Mortimer entertained Washington, Lafayette, and Comte de Rochambeau, Jean Baptiste Donatien de Vimeur, which undoubtedly helped Mortimer to be elected mayor the next year.

By the time Fredericksburg was chartered as an incorporated city by the General Assembly in 1782, it had around 1,000 residents. Wheat and other commodities replaced tobacco as the foundation of the local economy. The *Virginia Herald*, one of the earliest newspapers in Virginia, began publication in Fredericksburg in 1787. Robert Brooke of Fredericksburg became governor of Virginia in 1794.

After the War of 1812, a new town hall with a market house was built on Princess Anne Street. Twelve years later, Lafayette was entertained in the city for two days on his triumphant tour of the United States. The boundaries of Fredericksburg were expanded by 1851.

Fredericksburg played a major part in the Civil War. Confederate president Jefferson Davis delivered an address to the town's people in 1862. Because of Fredericksburg's strategic location between Washington, D.C., and Richmond, which was the capital of the Confederacy, and because it had a railroad and river, the Union forces wanted control of the city. Fredericksburg survived two major battles of the Civil War, which were fought in and around the city. The first battle occurred in December 1862. The second battle was fought in April 1863 as part of the Chancellorsville campaign. After the Civil War ended, about 4,000 of the 5,000 prewar civilians returned to the ruins of Fredericksburg, which was under the military jurisdiction of the federal government until 1879.

Fredericksburg became the second city in America to adopt a city council style of government in 1912. Decades later in 1971, a 40-block area was designated as a National Register Historic District.

C. O'Conor Goolrick, a member of the House of Delegates in the General Assembly of the State of Virginia, was instrumental in locating what is today the University of Mary Washington in Fredericksburg. It was originally established in 1908 as a teacher-training institution called the State Normal and Industrial School for Women at Fredericksburg. In 1944, the college merged with the University of Virginia. During the summer quarter of 1929, the college was opened for both men and women for the first time. Mary Washington College split from the University of Virginia in the 1970s. James L. Farmer Jr., who organized the nation's first civil rights sit-in, founded the Congress of Racial Equality, organized freedom rides to desegregate interstate bus travel, was one of the big four civil rights leaders of the 1960s, was assistant secretary of the U.S. Department of Health Education and Welfare, was awarded the Presidential Medal of Freedom, and was a distinguished professor of history and American studies at Mary Washington College. Mary Washington College officially became the University of Mary Washington in 2005. Today the university has over 4,000 students enrolled. The university can boast of having as one of its associate professors Claudia Emerson, who won the 2006 Pulitzer Prize for poetry.

Today Fredericksburg's population is more than 20,000. Thanks to John Smith, George Washington, James Monroe, the American Revolution, and the Civil War, the people who live in Fredericksburg can boast they live in America's most historic city.

One

COMING TO
FREDERICKSBURG

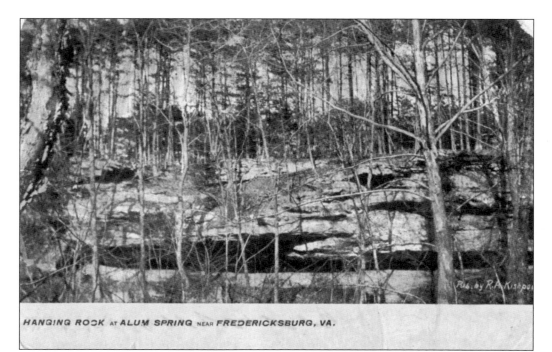

HANGING ROCK at ALUM SPRING near FREDERICKSBURG, VA.

ALUM SPRING. This rock outcropping called Hanging Rock is in Alum Springs Park, located just off Route 3 near its intersection with Jefferson Davis Highway. Local legend has it that a Native American princess and her lover were crushed to death under this rock. When the wind blows from just the right direction, you can hear her screams.

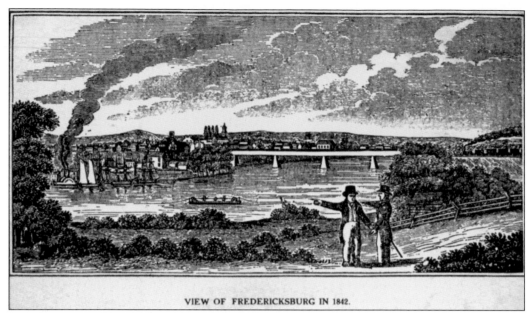

VIEW OF FREDERICKSBURG IN 1842.

VIEW OF FREDERICKSBURG IN 1842. The town began with 50 acres from the 1671 Buckner-Royston Patent of 2,000 acres, known as "The Leaselands." It grew into a port town having a courthouse, clerk's office, jail, market house, orphan asylum, five churches, and two seminaries, one for men and one for women of the upper class. Trade goods included tobacco, flour, maize, and other grains. The population in 1830, including slaves and free blacks, was 3,308.

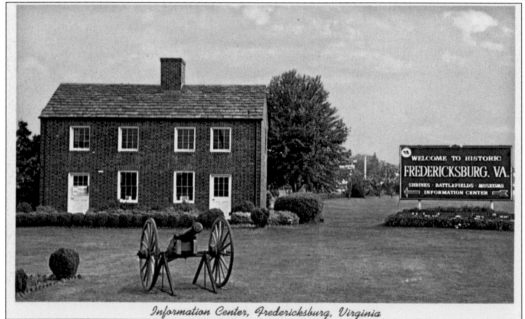

Information Center, Fredericksburg, Virginia

INFORMATION CENTER. The building seen in this postcard was, for a time, used for Fredericksburg's Information Center. It had been moved from the lot where the National Bank of Fredericksburg is located at the corner of Princess Anne and George Streets to the intersection of Princess Anne Street and Jefferson Davis Highway to give space for parking and drive-through windows for the bank. It now houses an insurance business.

FREDERICKSBURG VISITOR'S CENTER.
This building, located at 706 Caroline Street, was built in 1824 by Anthony Kale for use as his residence and shop after both sides of the block had been leveled by fire in 1823. Kale was a confectioner. After the fire, many of the buildings were built of brick in the Federal style, with shops on the ground floor and residences above.

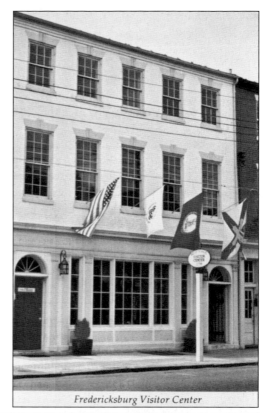

Fredericksburg Visitor Center

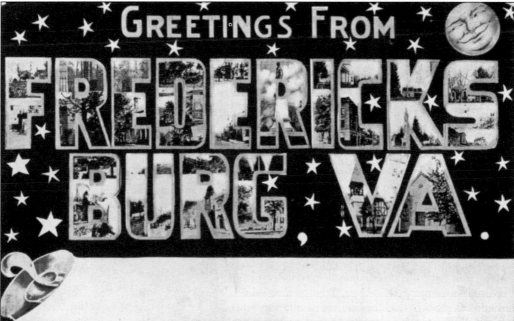

GREETINGS FROM FREDERICKSBURG, VA. Shown above is an example of an early, *c.* 1903, undivided-back postcard. The space at the bottom was the only place allowed for messages to friends and family. The back of the card was only for the address.

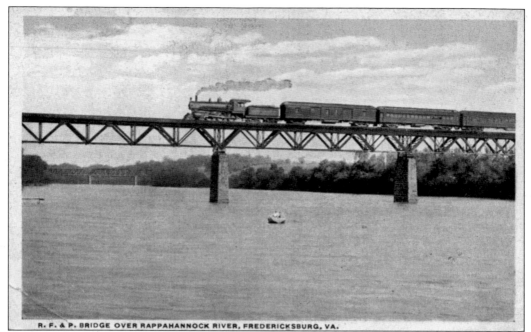

R. F. & P. BRIDGE OVER RAPPAHANNOCK RIVER, FREDERICKSBURG, VA.

THE RICHMOND, FREDERICKSBURG AND POTOMAC RAILROAD. The RF&P Railroad began construction from Richmond in 1834 and reached Fredericksburg within eight years. It was the major North–South route for people and goods. The railroad became the primary method of transportation. Today commuters use the train, the Virginia Railway Express, for transport to and from their jobs in Washington, D.C.

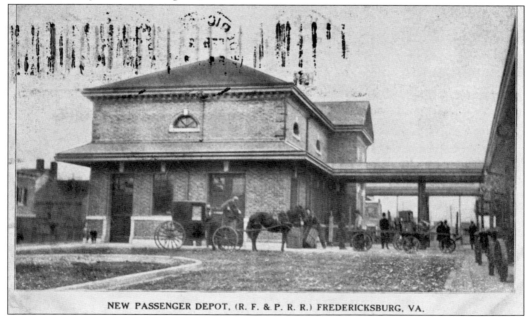

NEW PASSENGER DEPOT, (R. F. & P. R. R.) FREDERICKSBURG, VA.

RAILROAD DEPOT. This railroad depot was built in Fredericksburg in 1925. Regular railroad passenger service has operated since 1842. The Fredericksburg train depot, located in the 400 block of Princess Anne Street, was a busy place. Passengers and goods were checked through this building, which today houses Claiborne's Restaurant. (Bill Beck, Beck's Antiques.)

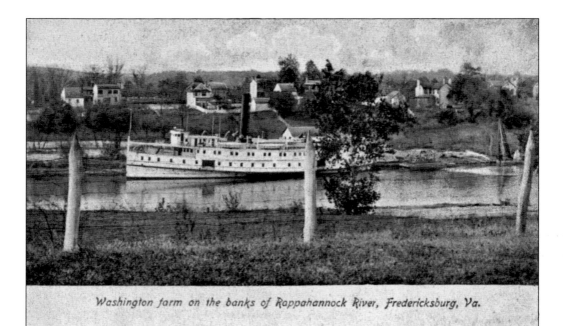

Washington farm on the banks of Rappahannock River, Fredericksburg, Va.

VIEW OF FREDERICKSBURG FROM STAFFORD. This card shows a steamboat carrying passengers and cargo on the Rappahannock River. Fredericksburg is in the background across the river seen from Ferry Farm on the Stafford side. Today a paddle-wheel boat called the *City of Fredericksburg* takes sightseers on pleasure cruises down the Rappahannock.

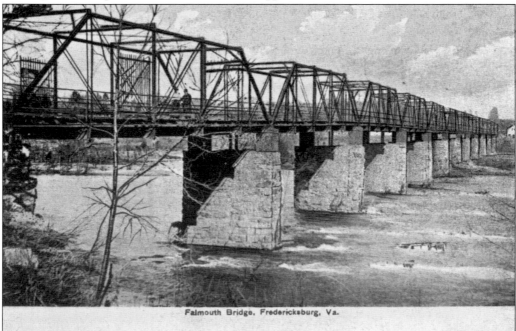

Falmouth Bridge, Fredericksburg, Va.

FALMOUTH BRIDGE. This bridge was just one of many versions that have spanned the Rappahannock River at this location. As early as 1748, ferries were the first means of transit for tobacco. This crop was deposited and inspected by public, bonded inspectors at Fredericksburg warehouses, then transported elsewhere.

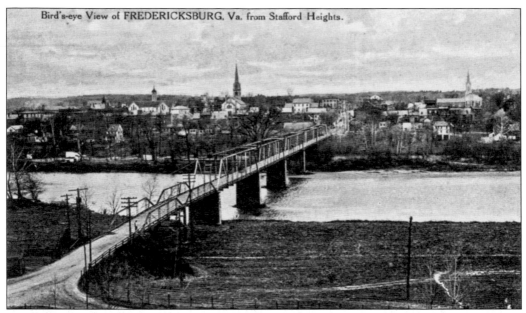

CHATHAM BRIDGE. The General Assembly successfully petitioned for a toll bridge to be built from the lower property line of William Fitzhugh of Chatham in 1796. This bridge stayed open until 1889. The City of Fredericksburg purchased the site of the toll bridge and built this bridge constructed of iron *c.* 1890. It was about 1,000 feet long and connected Stafford Heights to Fredericksburg near present-day William Street.

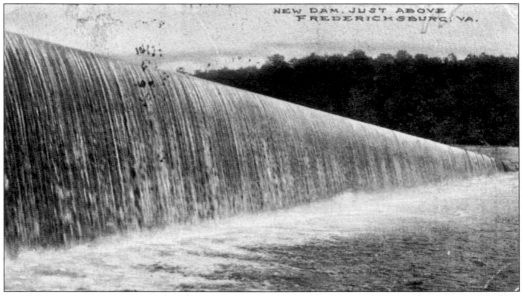

NEW DAM. A wood and stone crib dam was built on the Rappahannock River in 1855 by the Fredericksburg Water Power Company. By 1909, this new slab-and-buttress dam of concrete was built downstream to generate electricity for Fredericksburg and Falmouth industries. Frank Gould bought the company in 1910 and established the Spotsylvania Power Company. The City of Fredericksburg bought the dam, which was named for Judge Alvin T. Embrey, from Virginia Electric and Power Company in 1968. The Army Corp of Engineers blasted a section of the dam in 2004, and the dam removal was completed in 2005.

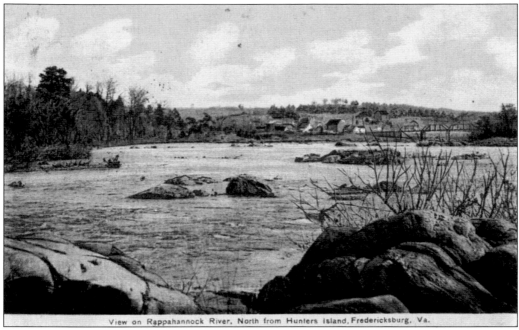

View on Rappahannock River, North from Hunters Island, Fredericksburg, Va.

TOWN ON RAPPAHANNOCK RIVER. This view showing buildings in the distance looks north from Hunters Island on the Rappahannock River.

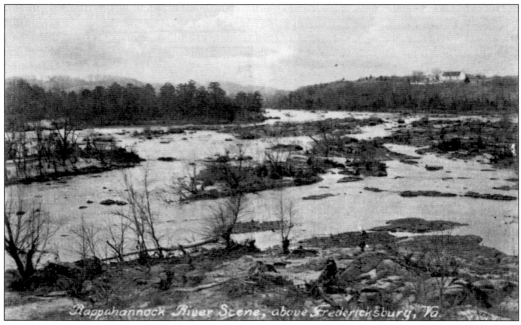

Rappahannock River Scene, above Fredericksburg, Va.

RAPPAHANNOCK RIVER. The Rappahannock River provided power for the many mills, which included Bridgewater Mills, Fredericksburg Paper Mill, Germania Mills, Hollingsworth's Mill, the early-19th-century Knox's Mill, Marye (Excelsior) Mills, Rappahannock Forge Mills, Thornton's Mill, Washington Woolen Mills, and the C. W. Wilder and Company Silk Mill.

15

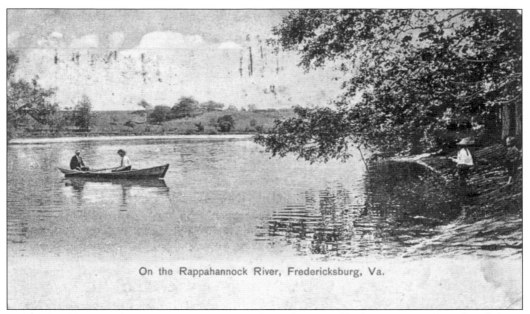

On the Rappahannock River, Fredericksburg, Va.

BOATS ON THE RAPPAHANNOCK RIVER. Falmouth, in Stafford County, and Fredericksburg both became port towns because of their proximity to the river. Today the river is used for many activities including boating, canoeing, kayaking, tubing, fishing, and swimming. On the Fourth of July, the river is the place to be to watch the popular raft race where contestants race their homemade vessels from the Falmouth Bridge to the Chatham Bridge. It is quite a sight.

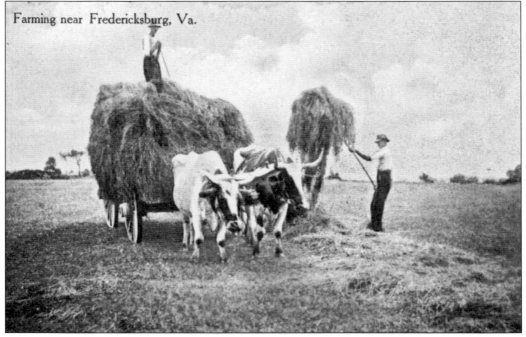

Farming near Fredericksburg, Va.

FARMING NEAR FREDERICKSBURG. This postcard and the next are probably generic cards, like many printed, which are interchangeable to almost any town. It shows an image that reflects the people and places of a point in time. Farming was very important in the establishment of Fredericksburg as a port town. Early crops included tobacco, corn, wheat, and other grains.

Good Fishing at Fredericksburg, Va.

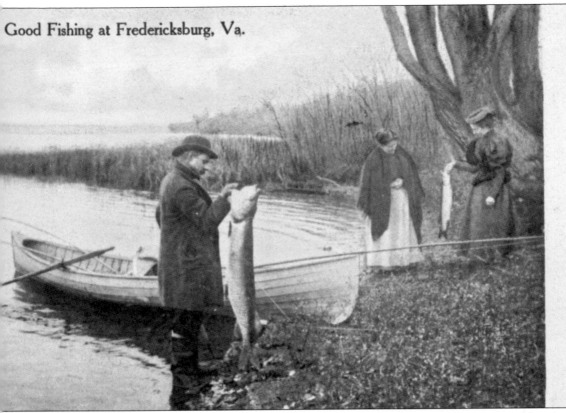

GOOD FISHING. Fishermen come to the Rappahannock River in the spring when the shad and herring make their run. Fishing, swimming, canoeing, and tubing are the favored sports on the river. The yearly Fourth of July River Raft Race brings entries and spectators from the Fredericksburg area. The Rappahannock Duck Race is a favorite fund-raiser. Thousands of hopefuls buy rubber ducks, set them afloat on the river, and await the news of whether their duck made it first across the finish point to win the prize.

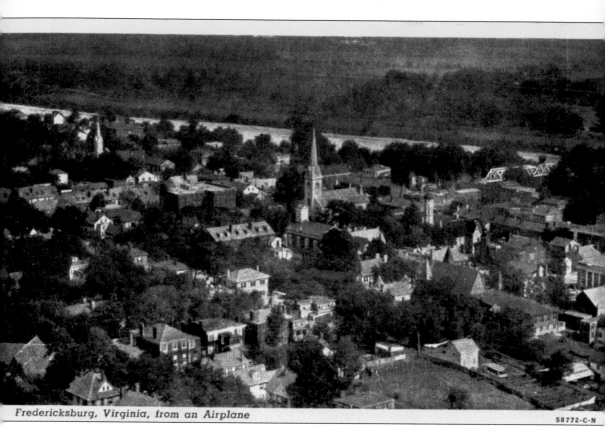

Fredericksburg, Virginia, from an Airplane

FREDERICKSBURG FROM AIRPLANE. This postcard from the early 1930s shows a very different Fredericksburg from the primitive port town that developed along the Rappahannock River. Today's Fredericksburg has grown far larger than the image on this card. Note the iron Chatham Bridge in the background at right in this card.

Two

CHURCHES

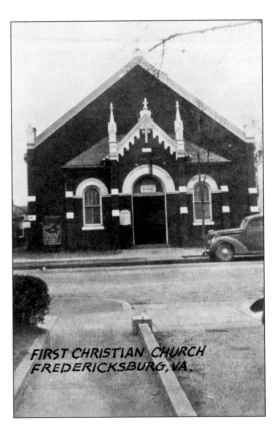

FIRST CHRISTIAN CHURCH. The First Christian Church moved to its present location at 1501 Washington Avenue near Kenmore in the early 1960s. A painting by Sidney E. King, a Caroline County artist, depicting a World War II soldier on the battlefield with Jesus standing larger than life nearby, hangs in the church. It is a powerful painting for anyone who has the opportunity to see it. Gary Staddan is the pastor of the church today.

FIRST CHRISTIAN CHURCH FREDERICKSBURG, VA.

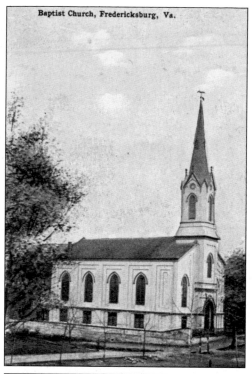

Baptist Church, Fredericksburg, Va.

FREDERICKSBURG BAPTIST CHURCH.
Fredericksburg Baptist Church, located at 1019 Princess Anne Street at the intersection with Amelia Street, was founded *c.* 1804. The church first began meeting in a frame building on Lafayette Boulevard where the Amtrak train station is located today. The church moved after 1818 to a meetinghouse at 801 Sophia Street where Shiloh (Old Site) Baptist Church is now located.

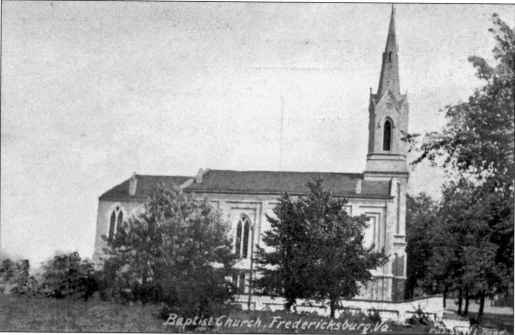

FREDERICKSBURG BAPTIST CHURCH, WEST VIEW. The church moved to its present building in 1855. Rev. William F. Broaddus became pastor in 1853. He was seized as a hostage by Federal authorities and imprisoned in Washington, D.C., in July 1862 during the Civil War. The church building suffered extensive damage during the artillery bombardment of the city and its subsequent use as a field hospital during battle in December 1862.

FREDERICKSBURG BAPTIST CHURCH, SOUTHEAST VIEW. After the Civil War, Fredericksburg Baptist Church was repaired under its new pastor, Rev. T. S. Dunaway, who ministered in it until 1898. The church has expanded over the years, acquiring property on Princess Anne Street next to the church, the quarter block across from the church, and the former Victoria Theater building on Caroline Street. Rev. Larry Haun came to Fredericksburg Baptist Church as a youth minister. He became pastor in 1984 and remains so today.

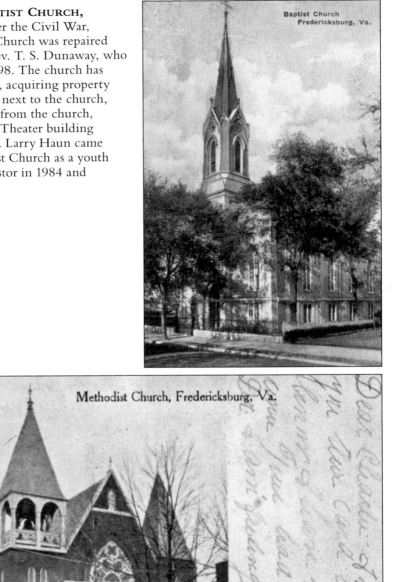

FREDERICKSBURG UNITED METHODIST CHURCH. This church on Hanover Street was finished *c.* 1841. The congregation split into the Northern Methodists and the Southern Methodists over the issue of slavery. After the Civil War, the churches united and occupied the George Street church until *c.* 1879, when the old church building on Hanover Street was torn down and replaced with this new one. Rev. John Kobler donated the parsonage on the same street.

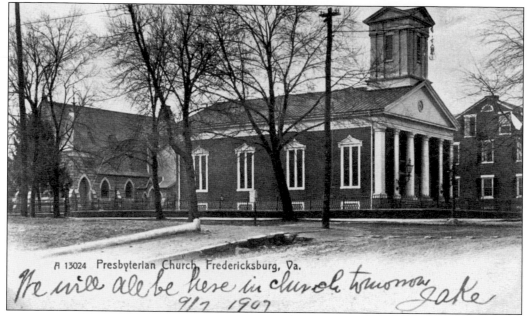

A 13024 Presbyterian Church, Fredericksburg, Va.

We will all be here in church tomorrow Jake 9/7 1907

PRESBYTERIAN CHURCH. This church, located at 300 George Street, was built in 1833. After the Civil War, Stonewall Jackson's former aide, James P. Smith, served as pastor from 1869 to 1891. The bell in the church was purchased by the ladies of Fredericksburg in 1870 to replace the bell given in 1862 to the Confederate states and melted for cannons. The church building is on the American Presbyterian Reformed Sites Registry of Historic Properties, the Virginia Landmarks Register, and the National Register of Historic Places.

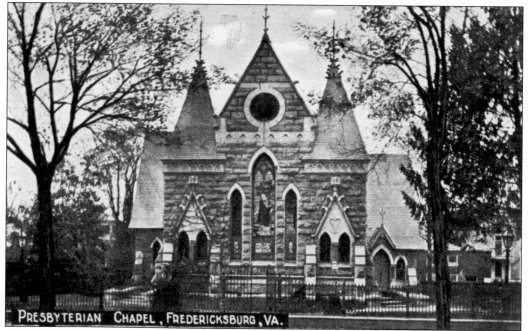

PRESBYTERIAN CHAPEL, FREDERICKSBURG, VA.

PRESBYTERIAN CHAPEL. This chapel was located on Princess Anne Street behind the Fredericksburg Presbyterian Church and a few feet from the firehouse before it burned in January 1954. The church is located at 810 Princess Anne Street but faces George Street.

22

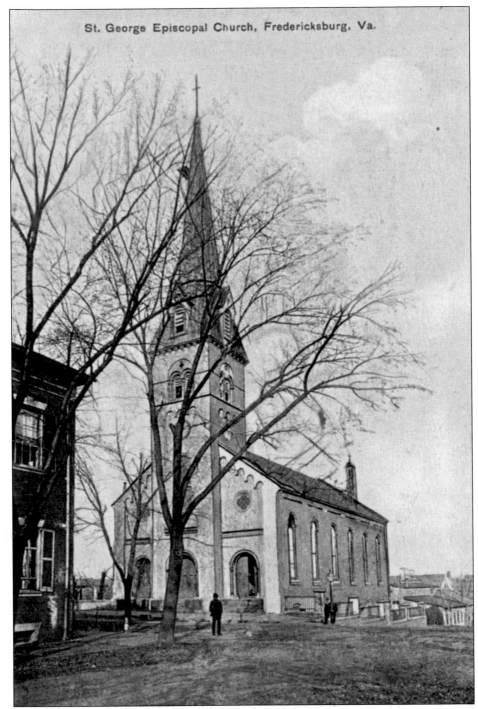

St. George Episcopal Church, Fredericksburg, Va.

ST. GEORGE'S EPISCOPAL CHURCH. St. George's, located at the corner of Princess Anne and George Streets, is built on the site of the first church in this area. The first church building was constructed *c.* 1726. The present one was completed in 1849 in the Romanesque style. One minister of the church cosponsored a Colonial slave school. Another minister helped to start the local chapter of the American Colonization Society in 1819.

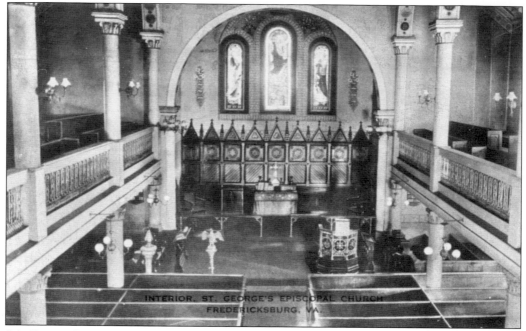

INTERIOR, ST. GEORGE'S EPISCOPAL CHURCH
FREDERICKSBURG, VA.

ST. GEORGE'S EPISCOPAL CHURCH INTERIOR AND GRAVEYARD. The interior of St. George's Episcopal Church retains much of its early appearance. St. George's has the oldest churchyard and cemetery in Fredericksburg. The cemetery dates to the early 18th century when the Anglican church was the only authorized house of worship. Col. John Dandridge, father of Martha Washington, is buried in the cemetery.

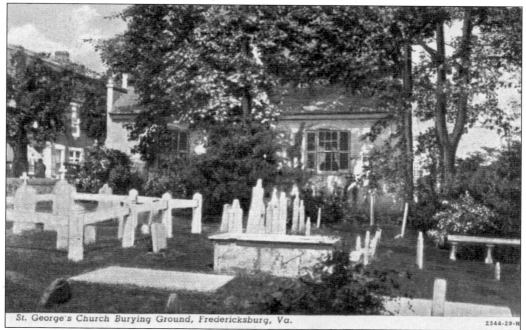

St. George's Church Burying Ground, Fredericksburg, Va.

2344-29-N

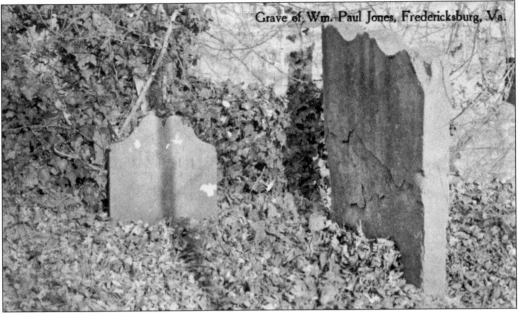

GRAVE OF WILLIAM PAUL JONES AT ST. GEORGE'S EPISCOPAL CHURCH. William Paul, a native of Scotland and brother of John Paul Jones, was a merchant in Fredericksburg. He purchased a lot on Caroline Street near the present Amtrak Station where he ran his business. He died in 1773 and was buried in the St. George's Episcopal Church Cemetery.

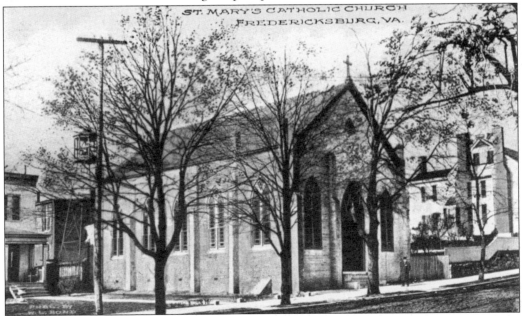

ST. MARY'S CATHOLIC CHURCH. St. Mary's began when the Right Reverend John McGill of Richmond preached a sermon in Fredericksburg, which led a group to form the church in 1859. They built a building on Princess Anne Street between Charlotte and Hanover Streets. The original parsonage burned in 1875, and a brick parsonage was then constructed. This structure is now used as an office building. St. Mary's Catholic Church is currently located at 1009 Stafford Avenue in the city. This postcard dates to *c.* 1910.

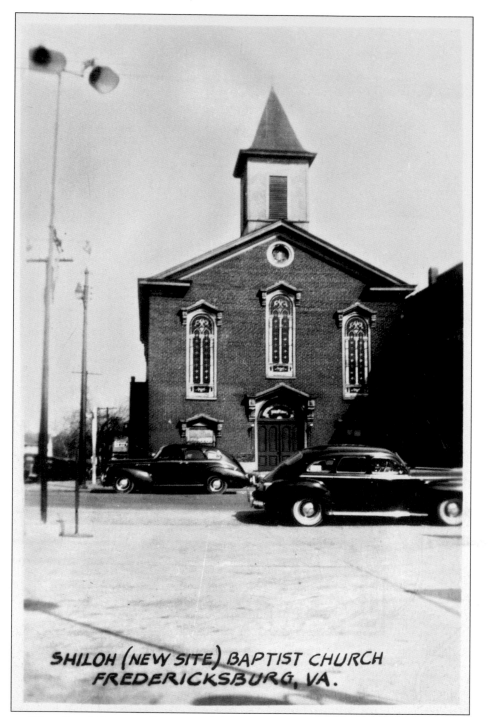

SHILOH (NEW SITE) BAPTIST CHURCH
FREDERICKSBURG, VA.

SHILOH (NEW SITE) BAPTIST CHURCH. Shiloh (New Site), located at the corner of Princess Anne and Wolfe Streets, was established after a split in the black congregation occurred. Judge William S. Barton fashioned a compromise acceptable to the two factions, and they divided the church and property. The terms "old site" and "new site" would be used to delineate the two Shiloh churches. Shiloh (Old Site) Baptist Church is located at the corner of Sophia and Hanover Streets.

Three

CIVIL WAR

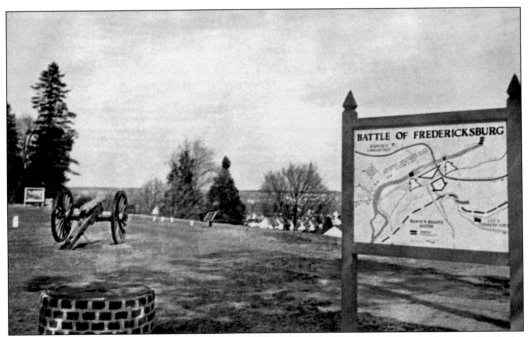

BATTLE OF FREDERICKSBURG. During the Battle of Fredericksburg on December 13, 1862, the Federal Irish Brigade and other units made assault after assault against the Confederate Georgia and South Carolina troops under the command of Gen. Thomas R. R. Cobb. The Confederate artillery on the heights and the infantry behind the stone wall beside the sunken road below repulsed the blue battle lines. General Cobb was killed in this action.

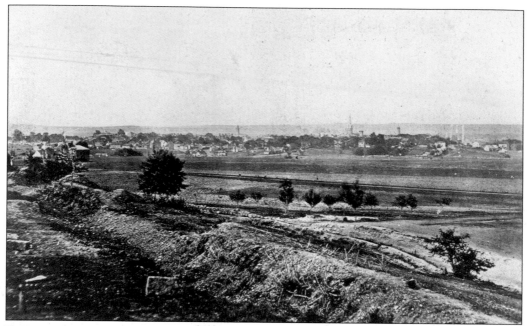

BATTLE OF FREDERICKSBURG VIEW FROM WILLIS HILL. This photograph postcard shows the town of Fredericksburg in a view from Willis Hill, which is now the National Cemetery. The sunken road can be seen in the foreground.

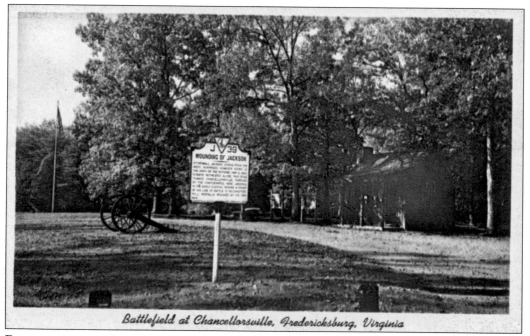

Battlefield at Chancellorsville, Fredericksburg, Virginia

BATTLEFIELD AT CHANCELLORSVILLE. This battle occurred in May 1863, just after the second Battle of Fredericksburg in April 1863. This marker is located west of Fredericksburg near the spot where Gen. Stonewall Jackson fell mortally wounded in the early evening of May 2, 1863. He was shot by his own men as he was moving in front of his own lines of battle to reconnoiter.

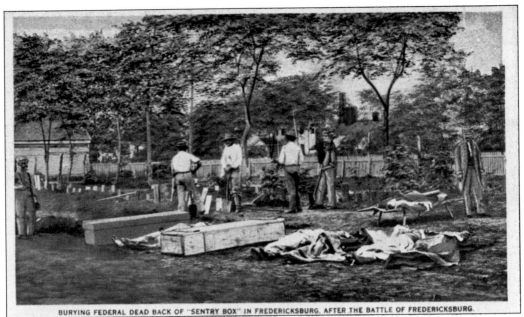

BURYING FEDERAL DEAD BACK OF "SENTRY BOX" IN FREDERICKSBURG, AFTER THE BATTLE OF FREDERICKSBURG.

BURYING FEDERAL DEAD. Slaves buried the dead in back of the Sentry Box in Fredericksburg after the Battle of Fredericksburg. Many of the dead were placed in temporary graves and later reburied in the National Cemetery, which was established after the Civil War. Eventually over 15,296 Union soldiers were buried in the National Cemetery. The identities of 12,000 of these remain unknown.

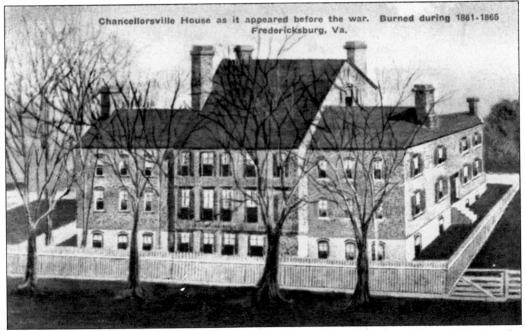

Chancellorsville House as it appeared before the war. Burned during 1861-1865
Fredericksburg, Va.

CHANCELLORSVILLE HOUSE. This tavern was a 17-room house before it burned during the Battle of Chancellorsville in May 1863. It was used as headquarters by Union general Joseph "Fighting Joe" Hooker. He was dazed by an exploding Confederate shell while standing on the front porch.

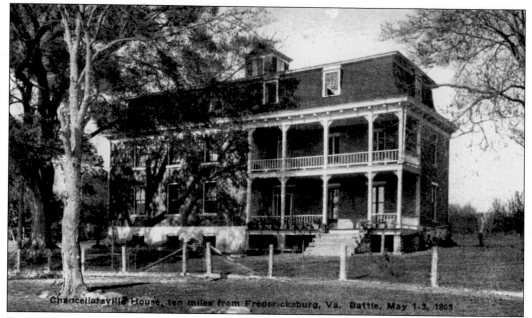

Chancellorsville House, ten miles from Fredericksburg, Va. Battle, May 1-3, 1863

EARLY CHANCELLORSVILLE HOUSE. Only the foundation of this house remains today. It was located on Plank Road (Route 3) about 10 miles west of Fredericksburg. It burned in 1863 during the Battle of Chancellorsville. Gen. Robert E. Lee's Army of Northern Virginia confronted Gen. Joseph Hooker and his Army of the Potomac at Chancellorsville.

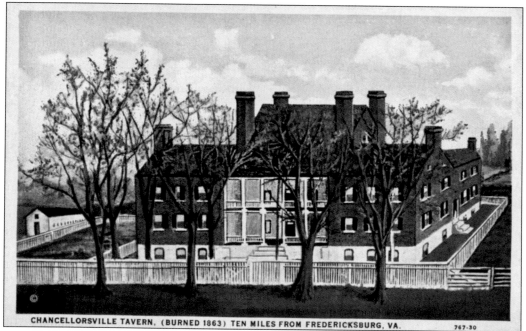

CHANCELLORSVILLE TAVERN, (BURNED 1863) TEN MILES FROM FREDERICKSBURG, VA. 767-30

CHANCELLORSVILLE TAVERN. Gen. Stonewall Jackson made his famous flank march on May 2 during the Battle of Chancellorsville, which resulted in a great defeat for the Federals. The victory was bittersweet for the Confederacy as General Jackson was accidentally shot by his own men that evening and died days later at Guinea Station. Note the smaller size of the Chancellorsville House in the top postcard prior to its enlargement before the war.

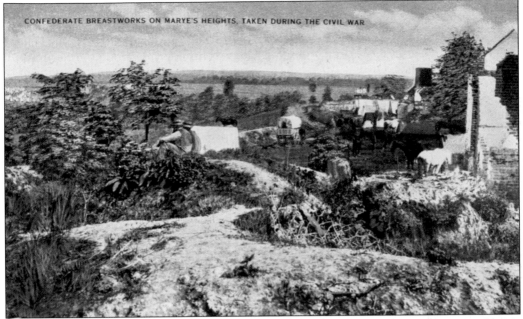

CONFEDERATE BREASTWORKS ON MARYE'S HEIGHTS. The image on this postcard was made from a photograph taken during the Civil War. (Gari Melchers Home and Studio, University of Mary Washington, Fredericksburg, Virginia.)

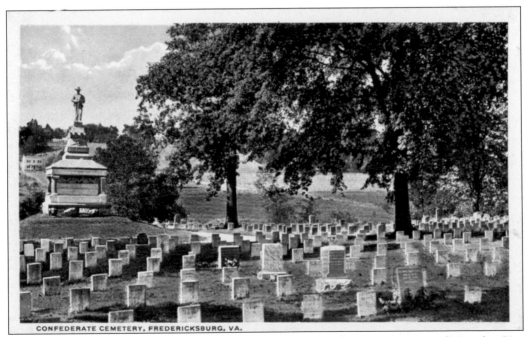

CONFEDERATE CEMETERY. This cemetery, located on Washington Avenue, adjoins the City Cemetery. Over 38,000 confederate soldiers died in the battles at Fredericksburg, Salem Church, Chancellorsville, the Wilderness, and Spotsylvania. After the war, the Ladies' Memorial Association of Fredericksburg raised money to buy property for the purpose of burying the Confederate dead. The graves were first marked with cedar posts.

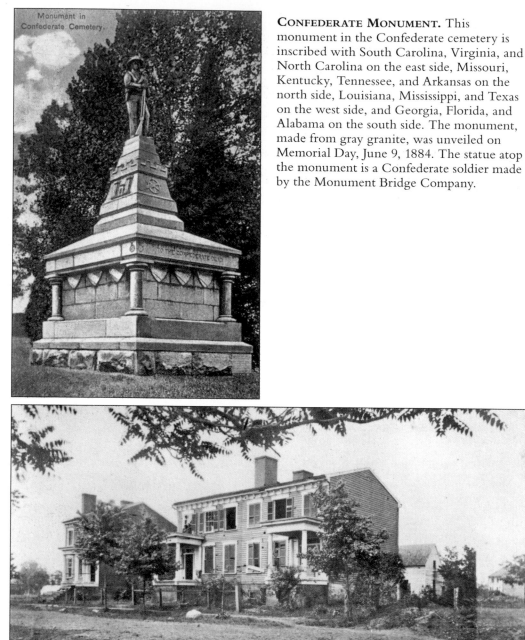

CONFEDERATE MONUMENT. This monument in the Confederate cemetery is inscribed with South Carolina, Virginia, and North Carolina on the east side, Missouri, Kentucky, Tennessee, and Arkansas on the north side, Louisiana, Mississippi, and Texas on the west side, and Georgia, Florida, and Alabama on the south side. The monument, made from gray granite, was unveiled on Memorial Day, June 9, 1884. The statue atop the monument is a Confederate soldier made by the Monument Bridge Company.

FOG HOUSE. After Gen. Ambrose Burnside's bombardment on December 11, 1862, Matthew Brady photographed the damage by Federal artillery to the Fog House located at 132–134 Caroline Street. Unable to drive out the Confederate sharpshooters who fired from roofs and windows, Federal artillery turned their guns on Fredericksburg from 7 a.m. to 1 p.m. Burnside's soldiers had tried to cross the Rappahannock River by building pontoon bridges. The Federals finally used the pontoons as boats to storm the shoreline.

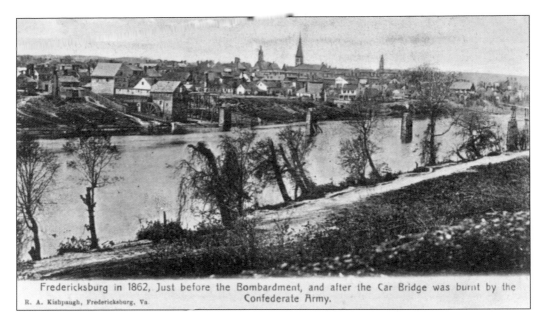

Fredericksburg in 1862, Just before the Bombardment, and after the Car Bridge was burnt by the Confederate Army.

R. A. Kishpaugh, Fredericksburg, Va.

FREDERICKSBURG 1862, BEFORE BOMBARDMENT. The Confederates destroyed the railroad bridge, leaving only the piers in the river. On December 12, 1862, the Confederate army, in a line that stretched from Fall Hill to Hamilton's Crossing, prepared to confront the Union army across the Rappahannock River. The Union army withdrew on December 15, when their advances on the Confederate positions failed. The citizens who had left their homes returned to find them stripped of everything. What was not taken by the Yankees was destroyed.

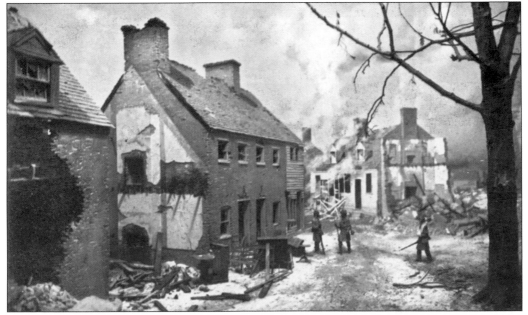

FREDERICKSBURG AFTER BATTLE OF 1862. This model was constructed from a photograph by the Museum Division, National Park Service, Department of the Interior, Washington, D.C. It shows the intersection of George and Hanover Streets on Tuesday morning, December 16, 1862, after the Union retreat. The model is displayed in the Fredericksburg and Spotsylvania Battlefield Visitor's Center on Lafayette Boulevard.

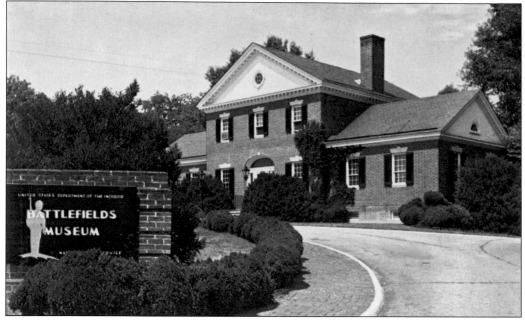

FREDERICKSBURG BATTLEFIELD VISITOR CENTER AND NATIONAL CEMETERY. Located on Lafayette Boulevard below Marye's Heights near Sunken Road, the Fredericksburg and Spotsylvania National Military Park was established in 1927 to preserve the local battlefields. It is administered by the Department of the Interior and includes parts of the four battlefields that are within 17 miles of Fredericksburg. The building, which houses a museum, was constructed in part by Civilian Conservation Corps labor in 1936.

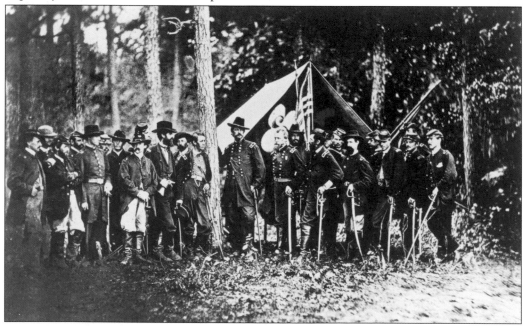

GEN. WINFIELD S. HANCOCK. This postcard shows Gen. Winfield Scott Hancock, center facing front, and his staff of 23 camped at Falmouth. Hancock commanded a Division of Union forces in front of the stone wall during the Battle of Fredericksburg in December 1862.

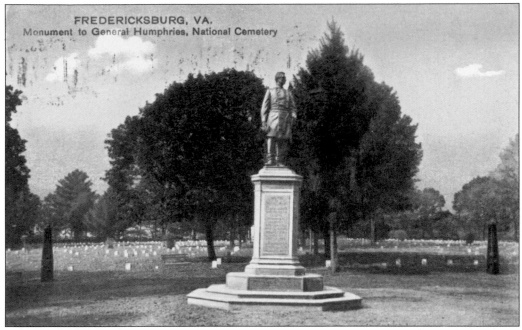

MONUMENT TO GENERAL HUMPHREYS. Union general Andrew Humphreys led his untested Pennsylvania army against the Confederate forces at Fredericksburg. Their effort was described as going against a wall of flame. This monument is in the National Cemetery on Lafayette Boulevard. This postcard dates to *c.* 1908.

STONEWALL JACKSON SHRINE. In this house at Guinea Station near Fredericksburg, Gen. Stonewall Jackson died on May 10, 1863. Jackson had been accidentally shot by his own men after the Battle of Chancellorsville days before. During his visit to this site in 1923, David Lloyd George, prime minister of Great Britain during World War I, said, "That old house witnessed the downfall of the Southern Confederacy."

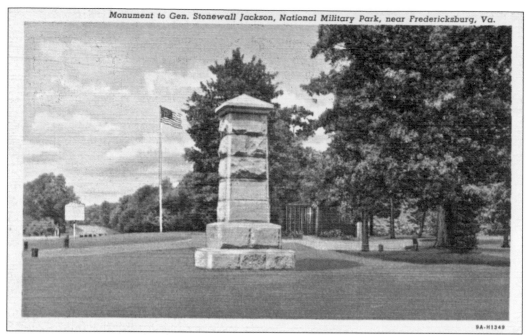

Monument to Gen. Stonewall Jackson, National Military Park, near Fredericksburg, Va.

9A-H1349

GEN. STONEWALL JACKSON MONUMENT. This monument near Chancellorsville in the National Military Park, 10 miles from Fredericksburg, marks the spot where Jackson fell mortally wounded by his own men on May 2, 1863. It was erected June 13, 1888.

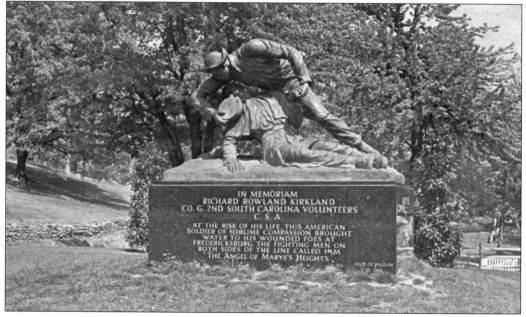

IN MEMORIAM
RICHARD ROWLAND KIRKLAND
CO. G. 2ND SOUTH CAROLINA VOLUNTEERS
C.S.A

AT THE RISK OF HIS LIFE, THIS AMERICAN
SOLDIER OF SUBLIME COMPASSION BROUGHT
WATER TO HIS WOUNDED FOES AT
FREDERICKSBURG. THE FIGHTING MEN ON
BOTH SIDES OF THE LINE CALLED HIM
"THE ANGEL OF MARYE'S HEIGHTS."

FELIX DE WELDON

KIRKLAND MONUMENT. Sgt. Richard Rowland Kirkland, of Company G, 2nd South Carolina Volunteers, risked his life to bring water to the wounded Union soldiers during a lull in the Battle of Fredericksburg in December 1862. Both the Union and Confederate soldiers called him the "Angel of Marye's Heights." Kirkland was later killed at the Battle of Chickamauga. This monument, created by Felix De Welden, is located on Sunken Road near the Fredericksburg and Spotsylvania Battlefield Park Visitor's Center.

LAST MEETING OF LEE AND JACKSON. Thomas Jonathan "Stonewall" Jackson commanded the right wing of the Confederate army at Fredericksburg in December 1862. This engraving from the painting by E. B. D. Fabrino Julio shows the Confederate generals Robert E. Lee and Jackson on the morning of May 2, 1863, near Chancellorsville. That night, after the Battle of Chancellorsville, Jackson was mortally wounded and died eight days later.

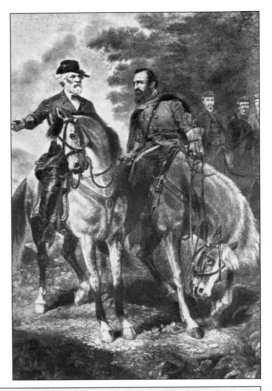

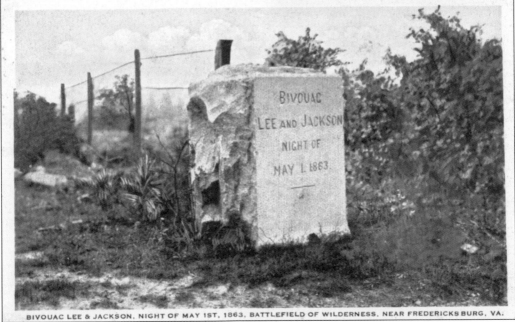

BIVOUAC LEE & JACKSON, NIGHT OF MAY 1ST, 1863, BATTLEFIELD OF WILDERNESS, NEAR FREDERICKSBURG, VA.

BIVOUAC OF LEE AND JACKSON. This marker commemorates the night of May 1, 1863, when Gen. Robert E. Lee and Gen. Stonewall Jackson met before the Battle of Chancellorsville. Lee would not know that Jackson would be dead days later. This postcard is incorrectly labeled "Battlefield of Wilderness." The Wilderness Campaign began in May 1864 on the old Chancellorsville Battlefield extending south and west.

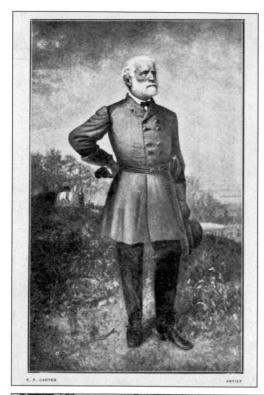

P. P. CARTER ARTIST

LEE AT FREDERICKSBURG. Gen. Robert E. Lee was made commander in chief of the military and naval forces of Virginia in April 1861 after the South seceded from the Union. He was later placed in command of the Army of Northern Virginia. Lee's master strategy helped his army defeat attacks by the Union army during the First Battle of Fredericksburg. His use of field fortifications as aids to maneuvering proved that a small body of men protected by entrenchments can hold an enemy force of many times their number, while the main body outflanks the enemy or attacks a smaller force elsewhere.

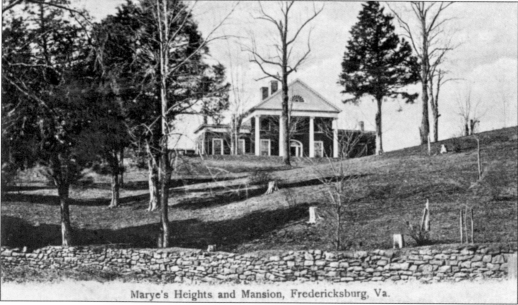

Marye's Heights and Mansion, Fredericksburg, Va.

MARYE'S HEIGHTS MANSION. John L. Marye, Virginia's lieutenant governor when the war began, owned this mansion. Marye's house was severely damaged by Federal artillery fire and gunshot. Gen. James "Pete" Longstreet used this home as his headquarters during the Battle of Fredericksburg in December 1862. The State of Virginia purchased and restored the house, now known as Brompton, in 1946 to use as the residence of the president of the University of Mary Washington.

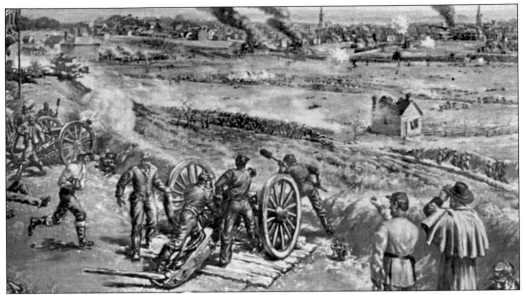

MARYE'S HEIGHTS, BATTLE OF FREDERICKSBURG. This painting by artist Sidney E. King depicts the scene on December 13, 1862, showing the defense of Marye's Heights by Gen. Robert E. Lee's Confederate army, which hurled back charge after charge of Gen. Ambrose Burnside's Federal army. In addition to many private works, Sidney E. King painted many scenes and murals for National Park Service sites around the United States.

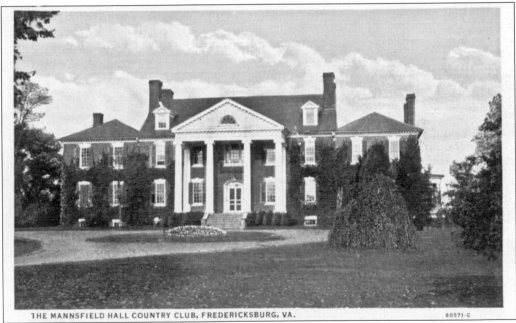

THE MANNSFIELD HALL COUNTRY CLUB, FREDERICKSBURG, VA. 60571-C

MANSFIELD HALL. The land upon which Mansfield Hall stood, known as Smithfield, was owned by the Brooke family. Smithfield was named after the octagonal Native American fort built on a portion of the property by Lawrence Smith in 1676. The fort had a stake palisade, and 50 men were always in it, while others tilled the surrounding lands keeping ready to respond to any sign of danger. Mansfield Hall was built after the prior mansion was damaged during the Battle of Fredericksburg. It is now the Fredericksburg Country Club.

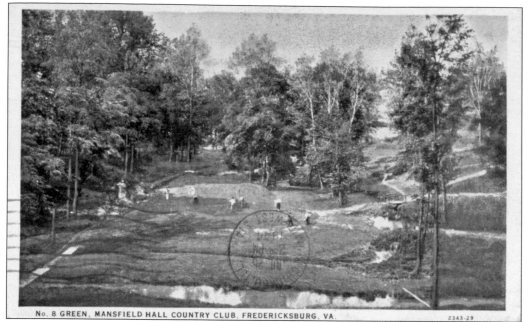

No. 8 GREEN, MANSFIELD HALL COUNTRY CLUB, FREDERICKSBURG, VA. 2343-29

MANSFIELD HALL COUNTRY CLUB. The estate formerly known as Mansfield became the Mansfield Hall Country Club. It was later purchased by the Fredericksburg Country Club. Today members of the Fredericksburg Country Club can enjoy swimming, tennis, and golfing.

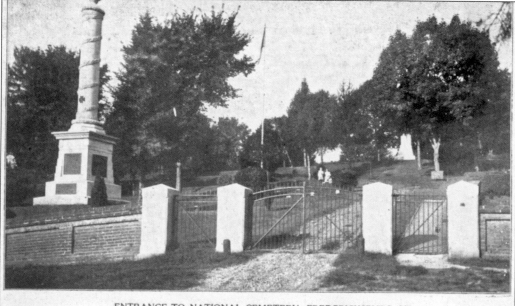

ENTRANCE TO NATIONAL CEMETERY—FREDERICKSBURG, VA.

NATIONAL CEMETERY ENTRANCE. Congress authorized the establishment of the National Cemetery in Fredericksburg on Willis Hill in July 1865. This was to be the burial ground for over 15,000 Union soldiers who died in the area during the Civil War. The identities of 83 percent of the soldiers are unknown. After the war, freed African Americans were employed to bury Union soldiers in the National Cemetery. The first black officer to be buried in this cemetery was Urbane Bass, a Fredericksburg doctor who died in 1918 while serving in World War I.

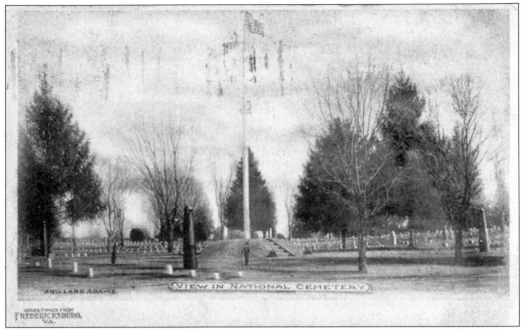

NATIONAL CEMETERY. This cemetery is located on Willis Hill in the area just south of Marye's Heights, above Lafayette Boulevard near Sunken Road. It contains over 15,000 remains of Federal soldiers who fought at Fredericksburg and the other battles in the area. Of the remains interred in the National Cemetery, the names of 12,798 are unknown. Acres of simple square headstones mark the graves on the rolling terrain. Statues of prominent officers were later additions. The Butterfield Monument was erected to honor the Fifth Army Corps and "the valor of every American soldier" according to Gen. Daniel Butterfield. Butterfield commanded this corps and paid $11,000 to erect the monument in 1901.

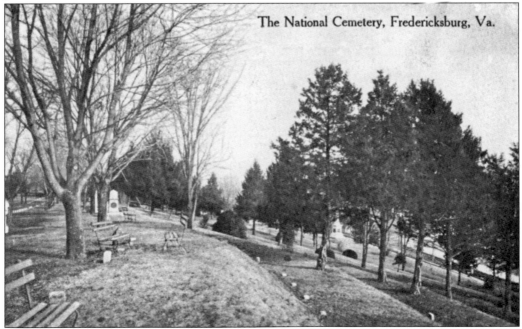

The National Cemetery, Fredericksburg, Va.

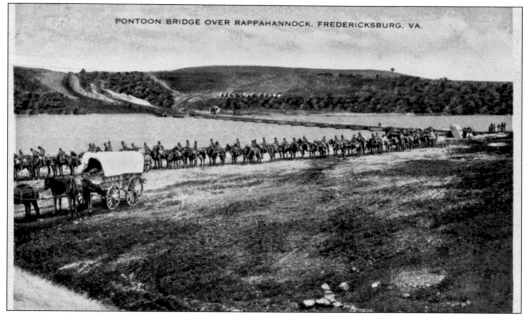

PONTOON BRIDGE OVER RAPPAHANNOCK. Union engineers brought pontoons in by wagons to build a bridge across the Rappahannock River. They were, however, delivered late, giving the Confederates time to prepare for the ensuing battle. The Confederate sharpshooters prevented Union engineers' attempts to construct the pontoon bridge by laying planks across the pontoons. The Union forces abandoned this effort, jumped in the pontoons, and paddled them across the river under fire, creating one of the first amphibious assaults of the Civil War.

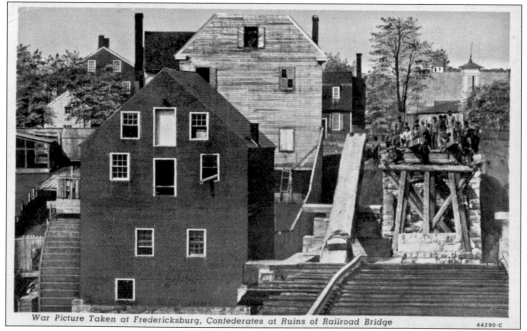

War Picture Taken at Fredericksburg, Confederates at Ruins of Railroad Bridge

44290-C

RUINS OF RAILROAD BRIDGE. This postcard, taken from a wartime photograph, shows Confederates at the ruins of the railroad bridge. The bridge had been destroyed by the Rebels to prevent the Yankees from crossing the river.

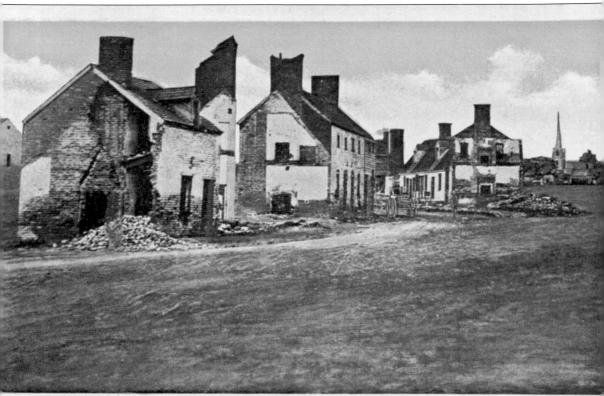

Ruins in Fredericksburg, Va., After Battle 1862

RUINS IN FREDERICKSBURG. Fredericksburg was in shambles after Union general Burnside's bombardment. This postcard shows the devastation at the corner of Hanover and George Streets, which is near the playgrounds of the former Maury School building. This street was the main wagon road going west out of Fredericksburg. These early-19th-century buildings were all demolished.

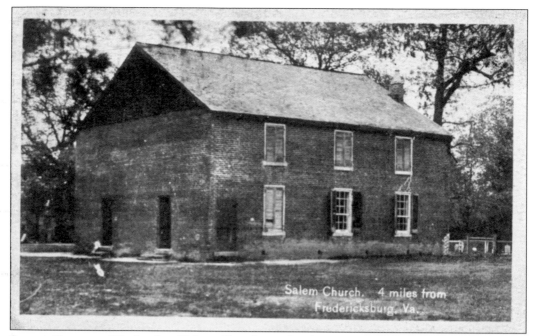

Salem Church. 4 miles from Fredericksburg, Va.

SALEM CHURCH. The battle of Salem Church was fought near Plank Road just after the Second Battle of Fredericksburg. Two monuments were erected after the Civil War to honor the 15th and 23rd New Jersey Volunteers. The postcard below shows the 15th Regiment of the New Jersey Volunteers on Route 3 near the church. This scene is a far cry from the eight-lane paved highway and dense swath of commercial stores and businesses that go miles beyond Salem Church today.

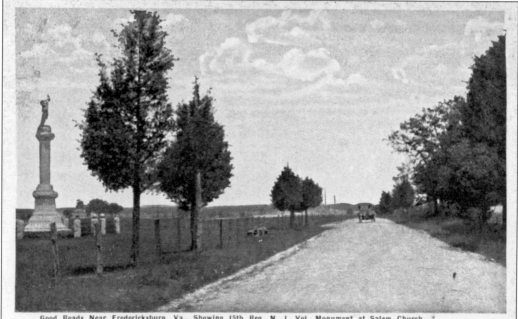

Good Roads Near Fredericksburg, Va., Showing 15th Reg. N. J. Vol. Monument at Salem Church.

MONUMENTS TO 15TH AND 23RD REGIMENT NEW JERSEY VOLUNTEERS. These monuments stand on Route 3 at Salem Church to mark the fighting of the 15th Regiment of the New Jersey Volunteers and the 23rd Regiment of the New Jersey Volunteers to honor the men who fought in the Battle of Salem Church.

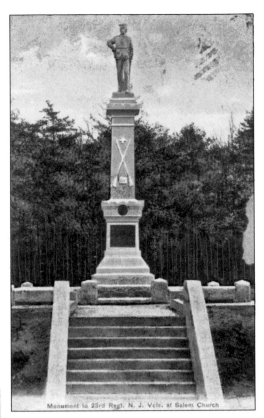

Monument to 23rd Regt. N. J. Vols. at Salem Church

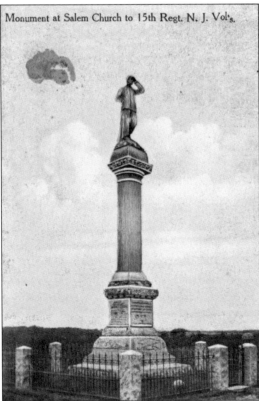

Monument at Salem Church to 15th Regt. N. J. Vol's.

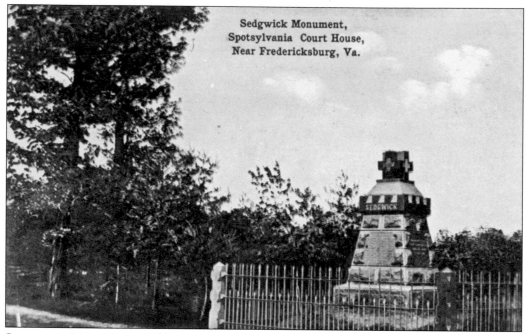

Sedgwick Monument,
Spotsylvania Court House,
Near Fredericksburg, Va.

SEDGWICK MONUMENT. This monument honoring Maj. Gen. John "Uncle John" Sedgwick, the commander of the Union VI Corps, who was killed by a Confederate sharpshooter at the Battle of Spotsylvania. He had just professed to his men that "snipers couldn't hit an elephant at this distance."

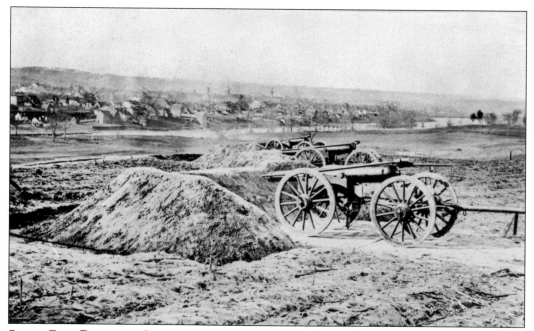

SIEGE GUN BATTERY OVERLOOKING FREDERICKSBURG. Secured behind gun pits, three cannons of Tyler's Connecticut Battery overlook the Fredericksburg of February 1863.

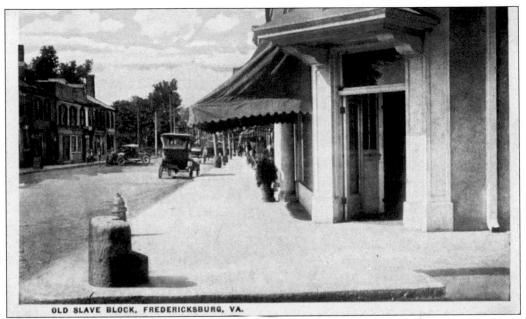

OLD SLAVE BLOCK, FREDERICKSBURG, VA.

SLAVE AUCTION BLOCK. The stone located at the corner of William and Charles Streets was used for the sale of property and the sale and hire of slaves until the Civil War. The William De Baptiste family, who were free blacks, lived at the southeast corner of Amelia and Charles Streets and held a secret school for African American youth in their home. The female students pretended to sew and the male students pretended to make matches in case the policeman stationed outside tried to catch them in their illegal school.

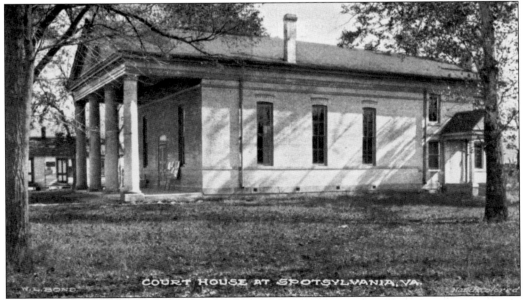

COURT HOUSE AT SPOTSYLVANIA, VA.

SPOTSYLVANIA COURT HOUSE. The small settlement of Spotsylvania Court House was where the region's main roads crossed. The Federals believed if they could reach it before the Confederates, they would be able to block them from their capitol in Richmond. But Brig. Gen. Fitzhugh Lee, nephew of commanding general Robert E. Lee, was able to hold the Federals with his cavalry until the infantry arrived to stop the advancing columns.

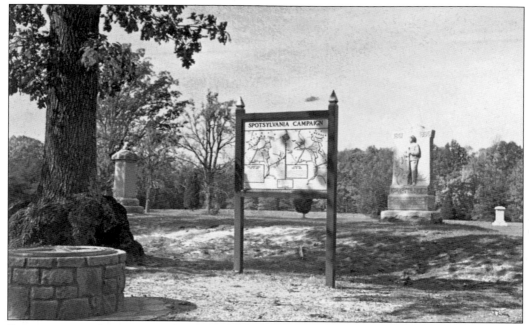

SPOTSYLVANIA CAMPAIGN. The marker that is seen in this postcard shows the battle movements of Federals and Confederates during the Spotsylvania campaign. The Bloody Angle at Spotsylvania Court House Battlefield, in the Fredericksburg and Spotsylvania National Military Park, occurred on May 12–13, 1864, and is considered one of the fiercest sustained hand-to-hand combats known to history. Many of the wounded were brought to Fredericksburg for treatment.

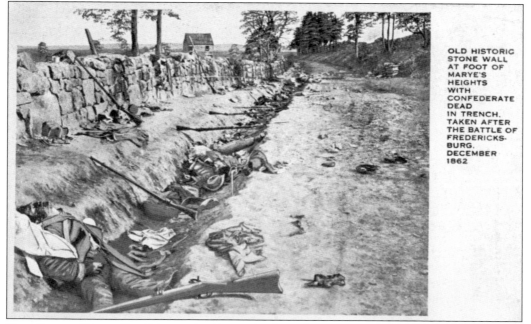

OLD HISTORIC STONE WALL AT FOOT OF MARYE'S HEIGHTS WITH CONFEDERATE DEAD IN TRENCH. TAKEN AFTER THE BATTLE OF FREDERICKSBURG. DECEMBER 1862

THE STONE WALL. Confederate dead lay at the foot of Marye's Heights along the stone wall in the sunken road after the Battle of Fredericksburg in April 1863. The photograph used in this postcard was actually taken after the Second Battle of Fredericksburg. It was often, however, as in this postcard, stated to depict the scene after the first battle in December 1862.

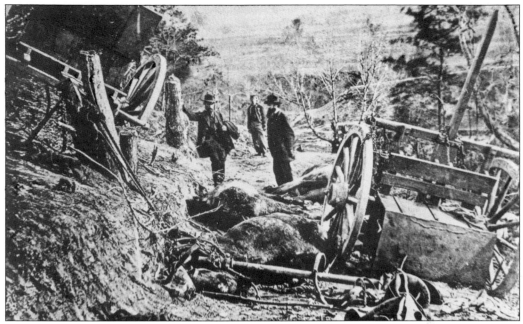

Sunken Road. The battles over Fredericksburg were fought in this area in 1862 and 1863. The Innis House, a modest frame structure located on the sunken road near the stone wall, survived the intense battles. Only the foundation of Martha Stephens's home remained. She refused to leave during the battle, and her home became a refuge and makeshift hospital for the wounded. Eight thousand Union and 2,000 Confederate troops were killed in this area.

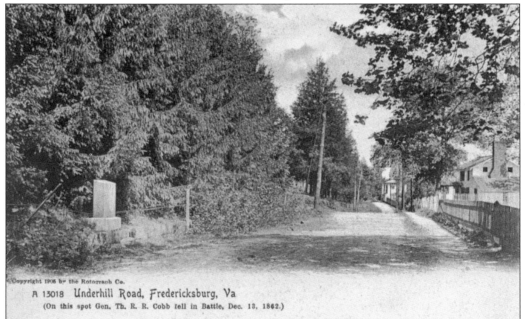

Copyright 1905 by the Rotograph Co.
A 13018 Underhill Road, Fredericksburg, Va
(On this spot Gen. Th. R. R. Cobb fell in Battle, Dec. 13, 1862.)

Underhill Road. This *c.* 1905 postcard shows Underhill Road, which became Sunken Road, near the infamous stone wall. On this spot, Confederate general Thomas Reade Rootes Cobb fell mortally wounded during the First Battle of Fredericksburg within sight of Federal Hill, which was his mother's home.

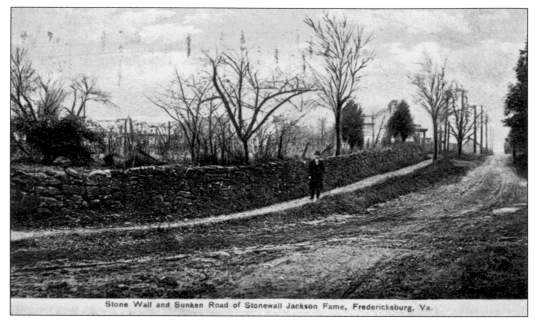

Stone Wall and Sunken Road of Stonewall Jackson Fame, Fredericksburg, Va.

STONE WALL AND SUNKEN ROAD. The area seen in this early postcard shows a post–Civil War view of the famous stone wall on Sunken Road. The road was later paved. Recently, the pavement was removed, and the road was closed to automobile traffic to depict it as it was then. Stonewall Jackson was not associated with this stone wall as the postcard states. He received his nickname "Stonewall" at the First Battle of Manassas.

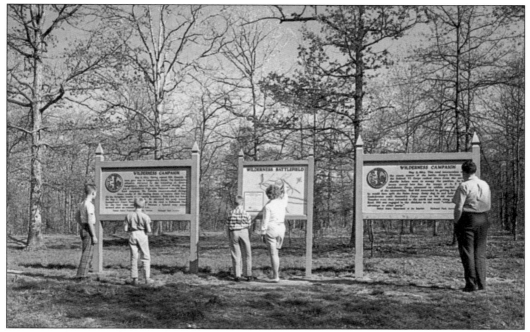

WILDERNESS CAMPAIGN. The armies commanded by Generals Robert E. Lee and Ulysses S. Grant suffered heavy losses during the battles fought in the Wilderness Campaign beginning in May 1864. As in the other battles in the area, those wounded at the Wilderness were brought to Fredericksburg for treatment of their injuries.

Four

EDUCATION

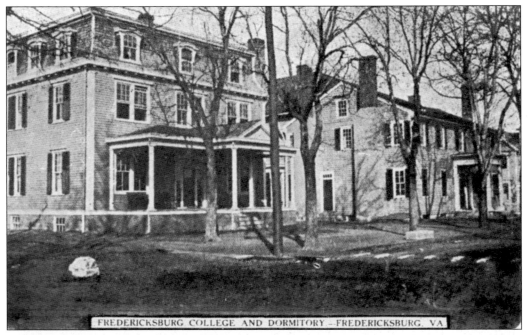

FREDERICKSBURG COLLEGE AND DORMITORY - FREDERICKSBURG, VA

FREDERICKSBURG COLLEGE AND DORMITORY. The Fredericksburg College began in 1893. Seen at left is the women's dormitory, which was located at the corner of Lewis and Prince Edward Streets. The main academic building at right was the Chew House and later Stoner's Store Museum. The college closed in 1914. The building was later bricked and used by Dr. G. Blight Harrison and Dr. Frank C. Pratt for the Fredericksburg Medical Center in 1936. It was later renamed the Pratt Clinic in honor of Dr. Pratt, who was much loved.

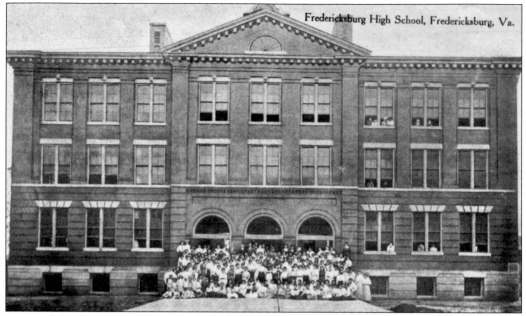

FREDERICKSBURG HIGH SCHOOL. This school building, built in 1907 at 1201 Caroline Street, housed all grades. After the new high school opened, it housed grades one to nine and later became Lafayette Elementary School. Hortense Key, Miss Darter, Florence Scott, Virginia Nash, Mrs. Greene, and Miss Cloe taught there in the 1950s. Ethel Nash was principal. The Central Rappahannock Regional Library took over the building in 1969 and remains there today.

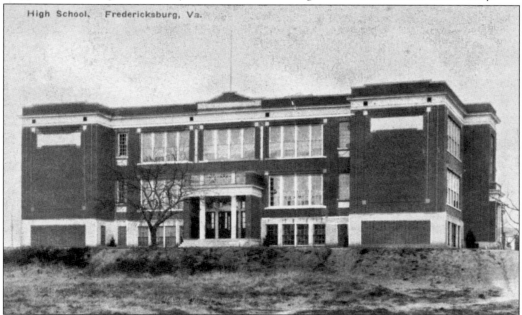

FREDERICKSBURG HIGH SCHOOL. This school building, located at the corner of Barton and George Streets, has had several names: Fredericksburg High School, James Monroe High School, and Maury Elementary. The rear part of what is now known as the Maury School was erected some years after the front. It was built on a potter's field. When the foundations were dug, human bones were unearthed. The football field has also had bones surface.

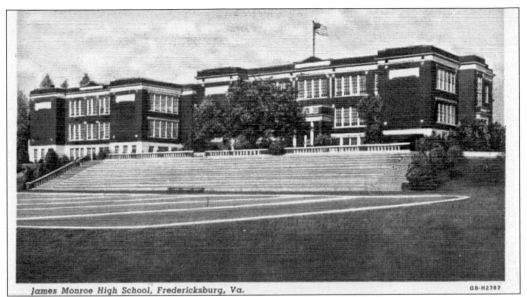

James Monroe High School, Fredericksburg, Va.

JAMES MONROE HIGH SCHOOL. The first James Monroe High School was located in this building, now known as Maury School. A new building to house James Monroe High School was built at 2300 Washington Avenue in the early 1950s. Construction of another, larger James Monroe High School building at the same location was finished in 2006. Before the old building was razed, there was a sale of everything in it. Many former students took the opportunity to buy mementos of their high school days.

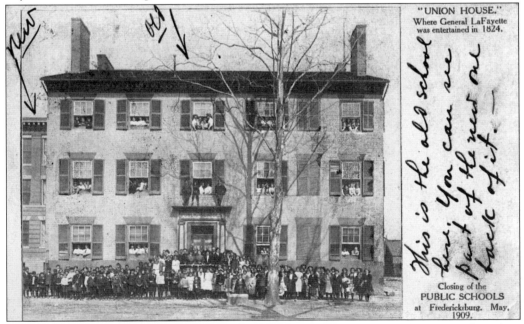

UNION HOUSE. The three-story brick building in this postcard was located at the corner of Caroline and Lewis Streets. In the first part of the 19th century, a Mr. Ross built the Union House as a residence. The home was later used as a school by the white children of the city. The Marquis de Lafayette used this building as his headquarters during his last visit to America. It was torn down when the new school, Lafayette School (seen at left), was built. (Bill Beck, Beck's Antiques.)

53

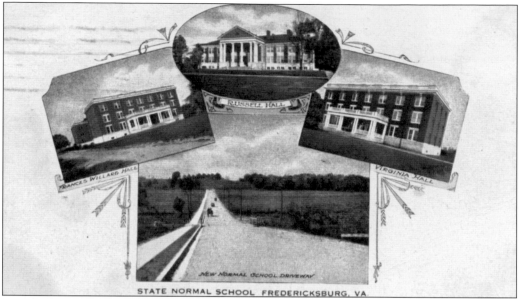

STATE NORMAL SCHOOL FREDERICKSBURG, VA.

STATE NORMAL SCHOOL. This multi-view postcard shows, from left to right, Frances Willard Hall, Russell Hall, and Virginia Hall of the State Normal School, which opened in 1908. In 1911, the main access road from William Street was a dirt road called Avenue C, which became College Avenue. The streets around the college, which originally had letter and number names, were changed in 1950.

STATE TEACHERS COLLEGE, FREDERICKSBURG, VA. SHOWING VIRGINIA HALL, MONROE HALL AND WILLARD HALL

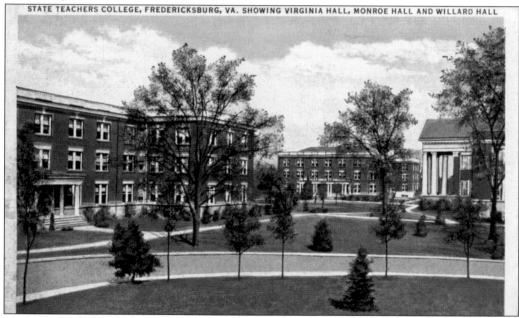

STATE TEACHERS COLLEGE. Edward Hutson Russell was the first president when the new State Normal School opened in 1908. It became the State Normal and Industrial School for Women in 1911 and the State Teachers College at Fredericksburg in 1924 after the Virginia General Assembly changed all of its normal schools to state teachers colleges. It became Mary Washington College in 1938 and Mary Washington College of the University of Virginia in 1944. Today it's the University of Mary Washington.

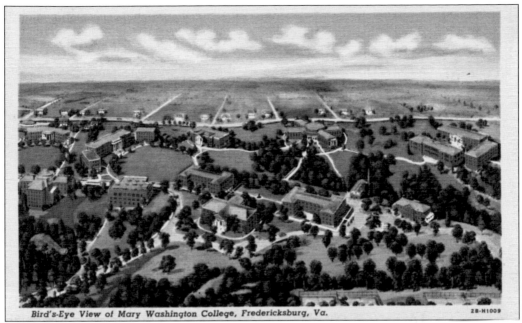

Bird's-Eye View of Mary Washington College, Fredericksburg, Va. 2B-H1009

MARY WASHINGTON COLLEGE, AERIAL VIEW. This 1930s postcard shows a much larger institution than the one that began in 1908 but one not as large as the university it became. The University of Mary Washington campus has grown to include 176 acres where more than 30 buildings rest in a park-like setting. The enrollment is over 4,000 students.

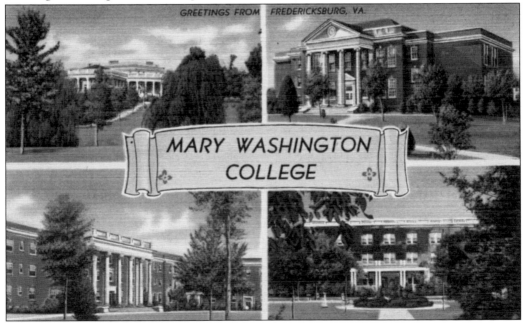

MARY WASHINGTON COLLEGE. As the college grew, a policy of desegregation was approved in 1964. The first African American graduated in 1968. Men were not admitted as full-time students until 1970, when Mary Washington was still a part of the University of Virginia. Mary Washington College was separated from the University of Virginia in April 1972. It then became an independent, state-supported institution with its own governing board.

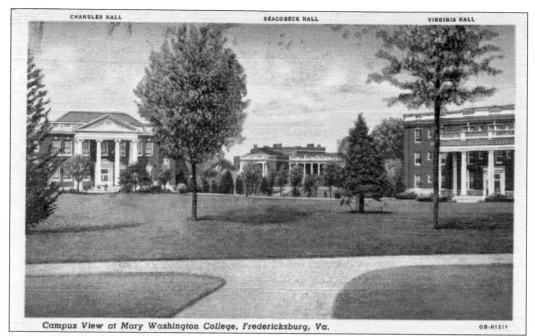

Campus View at Mary Washington College, Fredericksburg, Va.

CAMPUS VIEW AT MARY WASHINGTON COLLEGE. This postcard shows, from left to right, Chandler, Seacobeck and Virginia Halls. Today the university offers 35 undergraduate programs in the sciences and liberal arts. The Center for Historic Preservation at the university supports the undergraduate program in historic preservation and provides specialized services to preservation organizations and individuals.

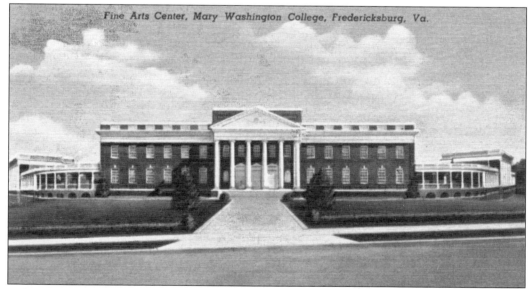

Fine Arts Center, Mary Washington College, Fredericksburg, Va.

DUPONT HALL. This is the fine arts building for the University of Mary Washington. The cornerstone was laid in 1951. Three units that make up the fine arts building were connected by colonnaded passageways on each side of the central unit. The middle front unit was named Jessie Ball DuPont Hall for Mrs. Alfred I. DuPont of Wilmington, Delaware, and Ditchley, Virginia, who was a native of the Northern Neck and the closest living relative of Mary Ball Washington, for whom the University of Mary Washington was named.

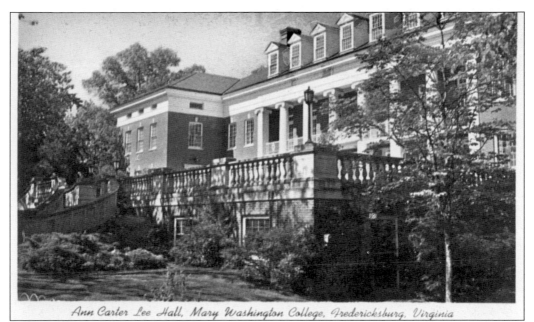

Ann Carter Lee Hall, Mary Washington College, Fredericksburg, Virginia

ANN CARTER LEE HALL. This building is used for lectures, dances, and other events. The hall, named in honor of Ann Carter Lee, the mother of Robert E. Lee, whose father was one of the richest men in Virginia. Her great-grandfather was Robert King Carter, and her mother was a descendant of Gov. Alexander Spotswood. In 1793, Ann married Gen. Henry "Light-Horse Harry" Lee, hero of the Revolutionary War, governor of Virginia (1791–1794), and later a member of Congress. Ann Carter Lee died in 1829.

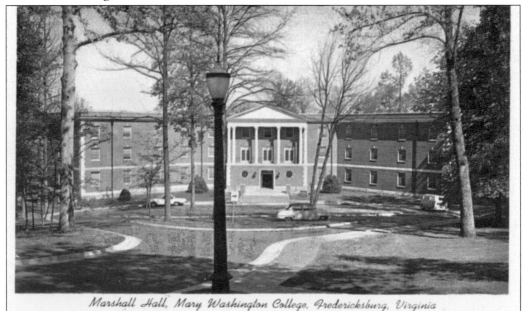

Marshall Hall, Mary Washington College, Fredericksburg, Virginia

MARSHALL HALL. This dormitory on the campus of the University of Mary Washington opened at the beginning of the 1960–1961 session and held 146 students. It was built near the corner of Sunken Road and William Street. The building was named for the wife of Chief Justice John Marshall, Mary Willis Ambler Marshall. Her grandfather had been governor of Virginia.

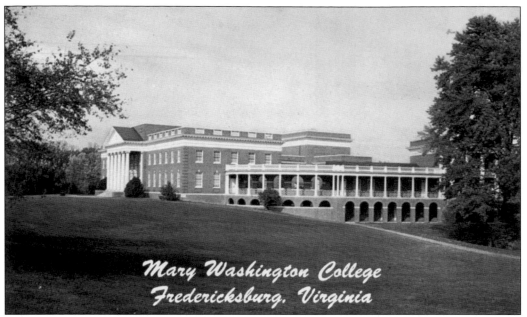

MELCHERS HALL. The south unit of the three units that make up the fine arts building on the University of Mary Washington Campus was named in honor of Gari Melchers. Melchers was an internationally known portrait artist. He lived at his country estate, Belmont, which still sits on the crest of a hill across the Rappahannock River in Falmouth. Melchers Hall is devoted to different styles of art, such as painting, ceramics, and sculpture, and the study of art history.

HUGH MERCER INFIRMARY. This building was named in honor of Hugh Mercer, a native of Scotland, who practiced medicine in Fredericksburg for about 15 years. The building, which is located on the campus of Mary Washington College on the hill behind Willard Hall, opened in 1950.

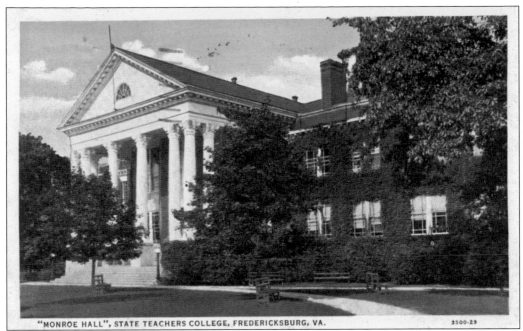

"MONROE HALL", STATE TEACHERS COLLEGE, FREDERICKSBURG, VA. 3500-29

MONROE HALL. This building houses classrooms at the University of Mary Washington. Emil Schnellock painted the murals on the entrance hall walls in Monroe Hall. His murals included a map of Virginia in geographical relief next to the seal of the Commonwealth of Virginia, with its motto "Sic Semper Tyrannis" and its triumphant virtus standing over the prostrate tyrant on one side. On the other side is a large representation of the Colonial seal of the Old Dominion, England's first colony in America.

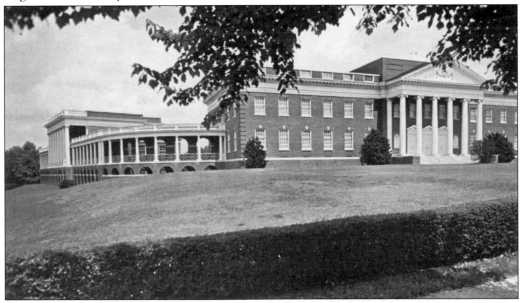

POLLARD HALL. The north unit of the three units that make up the fine arts building on the University of Mary Washington Campus was named in honor of John Garland Pollard. It is devoted exclusively to music. Pollard was governor of Virginia, attorney general, college professor, and patron of the arts.

59

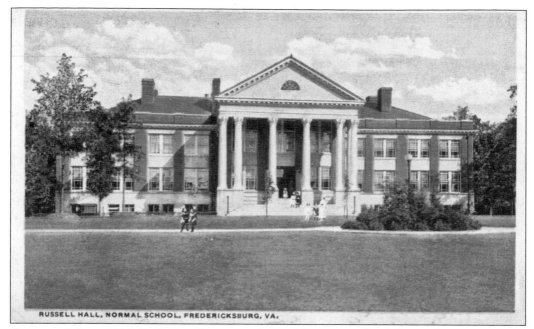

RUSSELL HALL, NORMAL SCHOOL, FREDERICKSBURG, VA.

RUSSELL HALL. This building, known today as Monroe Hall of the University of Mary Washington, was built *c.* 1919. It served as a dormitory and administrative building before being used for classrooms. When a new dormitory was built, it was given the name Russell Hall and had space for 179 students. It opened in September 1965 and had a swimming pool with an adjoining dressing room.

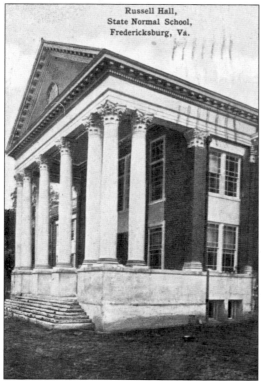

Russell Hall,
State Normal School,
Fredericksburg, Va.

RUSSELL HALL PORTICO. The new dormitory building was named for Edward Hutson Russell, first president of the institution. After a new dormitory was built, the name of Russell Hall was changed to Monroe Hall to honor the nation's fifth president, James Monroe.

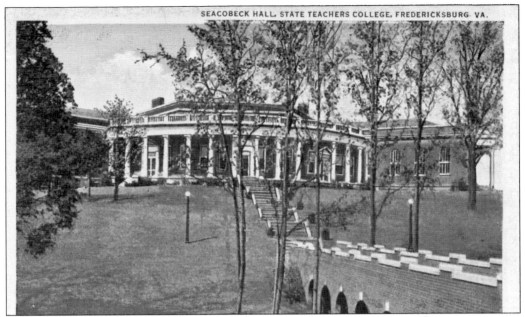

SEACOBECK HALL. This building serves as a dining hall on the campus of the University of Mary Washington. It was built out of the need for more adequate and modern dining and kitchen facilities in 1931. The site chosen was where the agriculture students tended a garden on campus close to College Avenue. The name of the hall came from the name of the Native American tribe from this area.

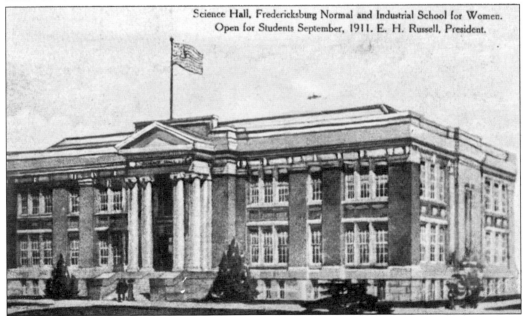

Science Hall, Fredericksburg Normal and Industrial School for Women. Open for Students September, 1911. E. H. Russell, President.

SCIENCE HALL. The Morgan L. Combs Science Hall building, which cost over $725,000, was completed in the summer of 1959. One of the new dormitories built across from the science hall was named in honor of Nina Gookin Bushnell, who had been dean of women. She was a strong and intimidating personality, and she was infamous (at least among young men who wished to date her charges).

61

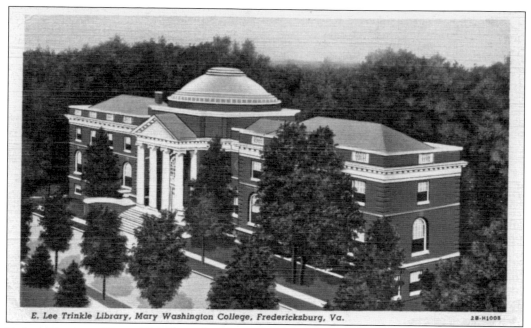

E. Lee Trinkle Library, Mary Washington College, Fredericksburg, Va.

2B-H1008

E. LEE TRINKLE HALL. The library building, completed in 1941, was named for former governor E. Lee Trinkle. Governor Trinkle had been influential in raising the funds needed to build a new library building on campus. Trinkle Hall later housed the history department. The bust of James L. Farmer Jr., who was an important American civil rights leader and distinguished professor of history and American studies at Mary Washington College, is in front of Trinkle Hall.

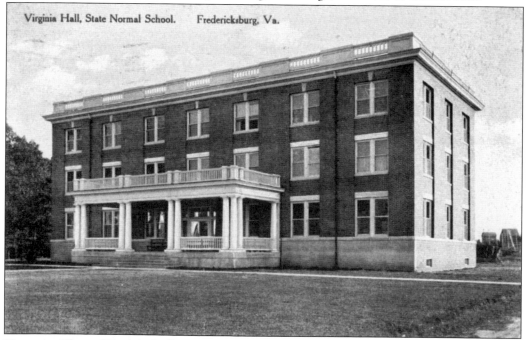

Virginia Hall, State Normal School. Fredericksburg, Va.

VIRGINIA HALL. Virginia Hall opened in 1915. It was one of the earliest buildings constructed on the campus of the State Normal School. It was originally called Dormitory Number 2. It was used as the library for a time during the college's early years.

GEORGE WASHINGTON HALL PORTICO.
The administration building of present-day University of Mary Washington was completed in 1941. The institution merged with the University of Virginia in 1944. Like Monroe Hall, it contains a mural painted by Emil Schnellock.

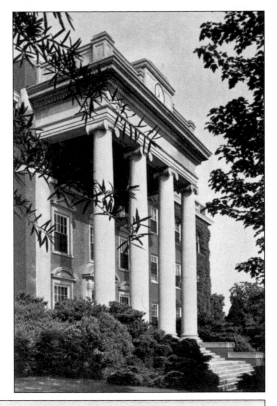

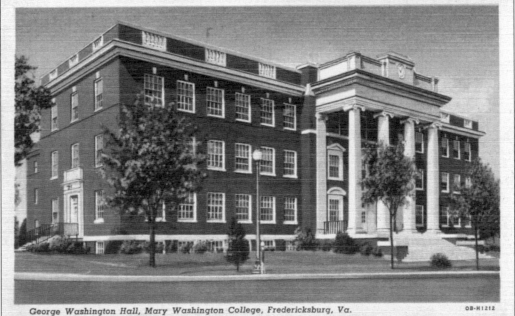

George Washington Hall, Mary Washington College, Fredericksburg, Va.

GEORGE WASHINGTON HALL. Mary Washington College grew to university status under the leadership of Pres. William Anderson, who retired in 2006. William John Frawley was inaugurated as the new president in September 2006. Today the University of Mary Washington has a student body of over 4,000.

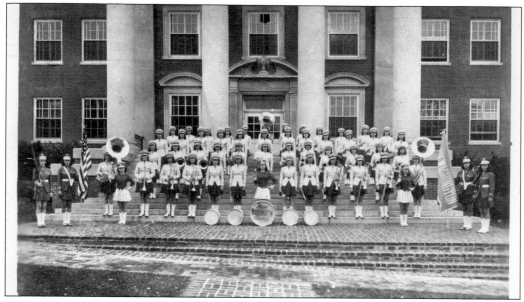

MARY WASHINGTON COLLEGE BAND. Ronald W. Faulkner, who came to Mary Washington in the fall of 1937, formed the first band. He is also credited with developing a concert orchestra and a dance orchestra. In April 1942, the band led a two-mile-long parade of 8,000 military troops, bands, and civilian organizations for the opening of the first big drive for the sale of war stamps and bonds in Richmond. The Mary Washington College Band was disbanded in 1958.

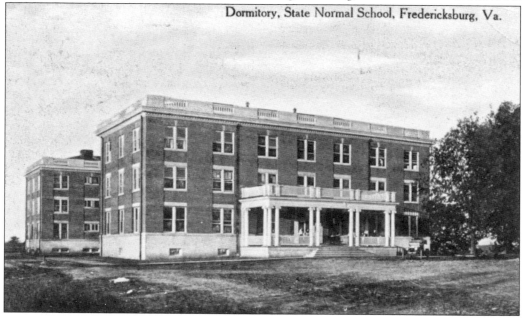

FRANCIS WILLARD HALL. This hall was used as a dormitory when the State Normal and Industrial School for Women opened in the fall of 1908. At one time, the college dining hall was at the rear on the first floor, and the post office was in the basement. Dalia L. Ruff served as assistant to the social director, assistant registrar, dietitian, assistant dean of women for nine years, and as housemother in Willard Hall. President Combs's family lived in Willard Hall during the renovations of the then president's residence.

Five

THE HOSPITAL

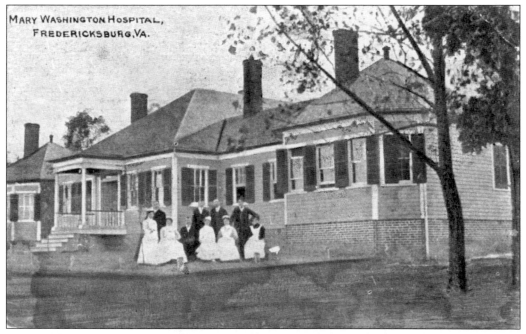

EARLY MARY WASHINGTON HOSPITAL. This postcard shows the hospital when it was still one story and located at the corner of Sophia and Fauquier Streets. The staff included Dr. W. J. Schesning, Dr. Hale, Dr. Andrew C. Doggett, Dr. J. N. Barney, Dr. J. Edward Tompkins, Bernici Kelmingham, Florence Harris, Rachel McCleary, Lelia Clift, Mrs. J. W. Masters, Virginia Aldridge, Mrs. English (housekeeper), and English's daughter. The cornerstone, laid in April 1899, was from the old Mary Washington monument.

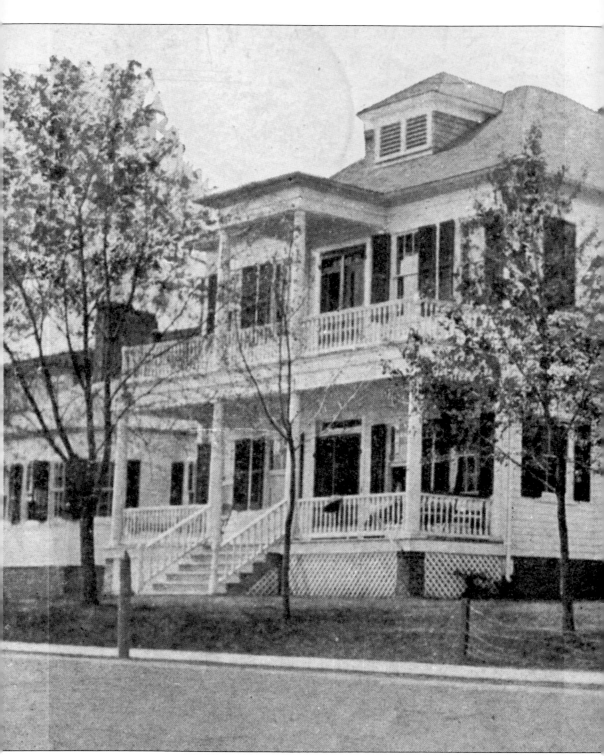

MARY WASHINGTON HOSPITAL. Mayor William Seymour White, who had been editor of the *Free Lance* and the *Star* newspapers, was one of the most influential people involved in the establishment of the hospital. The hospital was completed in 1900. Four versions of Mary

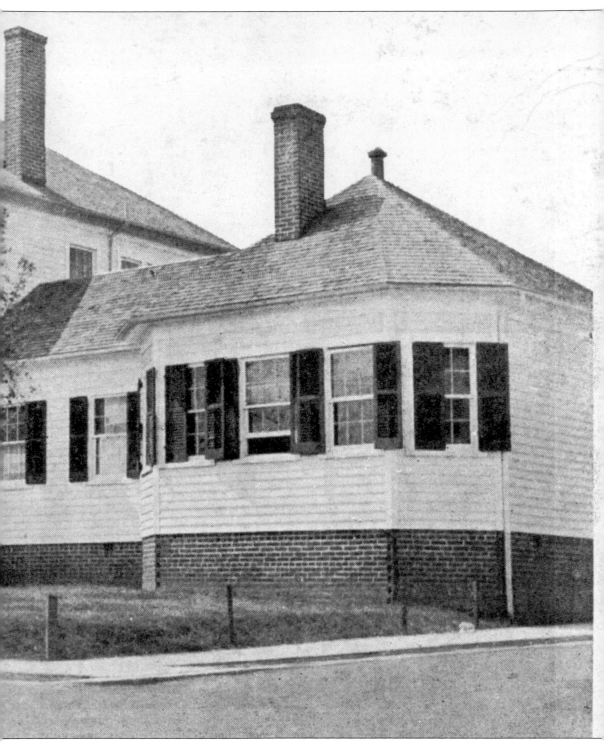

Washington Hospital have been built in Fredericksburg since. Because of the growing need for space, a second story was added to the hospital *c.* 1905, increasing the number of patients that could be accommodated to 10. The daily rate charge for a private room and bath was $6 in 1917.

NEW MARY WASHINGTON HOSPITAL. This hospital was the second version at the same location and constructed of brick in July 1928. The new hospital building, with its 75–bed capacity and the

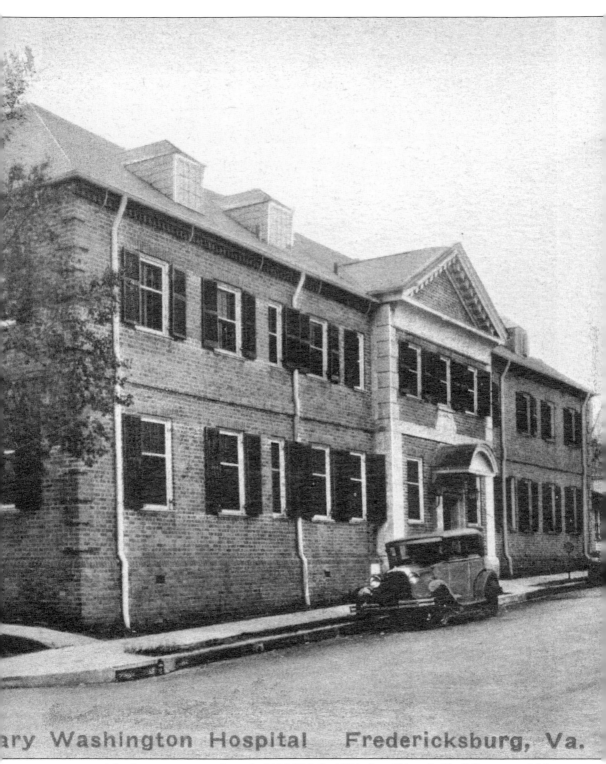

ary Washington Hospital Fredericksburg, Va.

two memorial wings, cost approximately $150,000. In 1954, the old hospital building was sold for $16,000 and converted into the Riverside Convalescent Home. This facility closed in 1977.

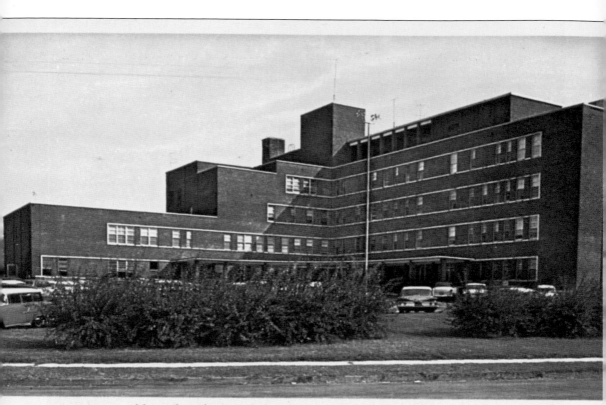

Mary Washington Hospital, Fredericksburg, Virginia

MARY WASHINGTON HOSPITAL ON FALL AVENUE. This is the third hospital and was built at 2300 Fall Hill Avenue. It opened in 1951 and cost approximately $1.7 million for the building's construction and the hospital equipment. This building is now used for offices, two of the tenants of which are the Fredericksburg Regional Chamber of Commerce and the Fredericksburg Regional Alliance, Inc. The fourth Mary Washington Hospital opened at 1001 Sam Perry Boulevard west of Snowden off U.S. Route 1 Highway in 1993.

Six

PEOPLE AND PLACES

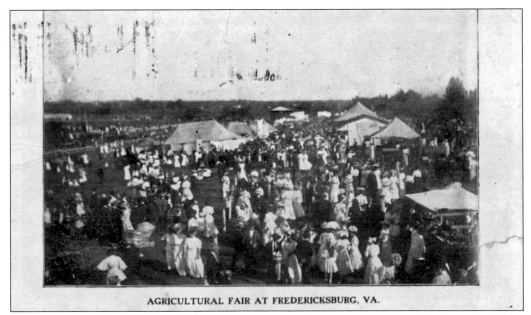

AGRICULTURAL FAIR AT FREDERICKSBURG, VA.

AGRICULTURAL FAIR. In 1738, the Virginia House of Burgesses passed a law directing "fairs should be held in Fredericksburg twice a year for the sale of cattle, provisions, goods, wares and all kinds of merchandise whatever." Agricultural fairs have been held on the grounds of Kenmore, Green Hill, on land east of Spotswood Street, the Amaret Farm on Fall Hill Avenue, where this photograph was taken, and now at the intersection of Route 2 and Lansdowne Road near Mayfield. (Bill Beck, Beck's Antiques.)

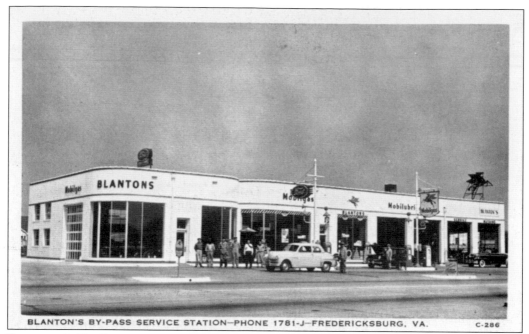

BLANTON'S BY-PASS SERVICE STATION—PHONE 1781-J—FREDERICKSBURG, VA. C-286

BLANTON'S BY-PASS SERVICE STATION. The gas station building seen in this postcard still stands at 417 Jefferson Davis Highway. The service station was owned by C. Rosser Massey. The building was later used as the Blanton Massey Ford Dealership. The U.S. Lighting and Electrical Supply store uses the building today.

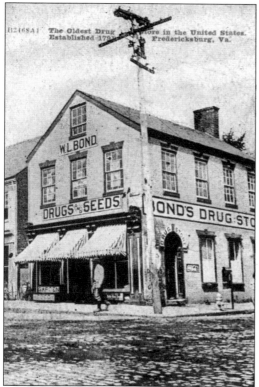

BOND'S DRUG STORE. Bond's Drug Store was touted as the oldest in the United States, being established in 1791. It was located at the corner of Caroline and William Streets. Like many of the early stores, it sold a variety of goods, not just drugs. Its owner and proprietor was "Dr." W. L. Bond, who was a pharmacist.

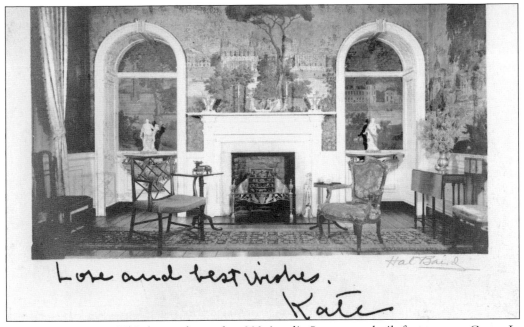

Love and best wishes.
Kate

DOGGETT HOUSE. This home, located at 303 Amelia Street, was built for attorney Carter L. Stevenson, *c.* 1817. The Doggett family owned it from 1888 to 1950. Kate Newell Doggett Boggs was the last Doggett owner. She wrote *Prints and Plants of Old Gardens*. Gari Melchers used this room for two of his paintings, *The Mammy* and *Madonna of the Rappahannock*, used on the cover of *Progressive Farmer Magazine*. (Gari Melchers Home and Studio, University of Mary Washington, Fredericksburg, Virginia.)

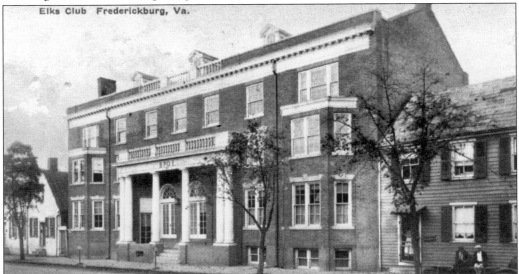

ELKS CLUB. This former men's club was located at 525 Caroline Street and was one of many fraternities in Fredericksburg in 1908. Knights of Pythias, Knights of Honor, Royal Arcanum, Senior and Junior Orders of American Mechanics, Laboring Men's Union, Heptasophs, Maccabees, Red Men, Knights of the Golden Horseshoe, and Good Samaritans were some of these groups. The Sons of Sobriety, a temperance order that originated in Fredericksburg, was first organized as a moderate drinking society. This building now houses Augustine's Restaurant.

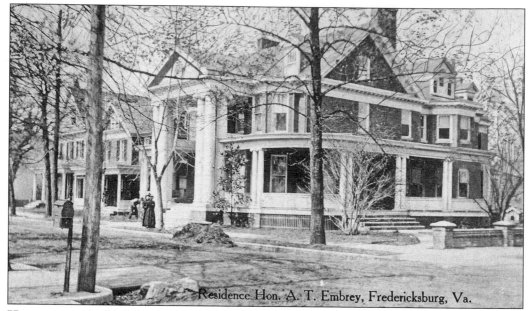

Residence Hon. A. T. Embrey, Fredericksburg, Va.

HONORABLE A. T. EMBREY HOME. This home, located on Hanover Street, was owned by the Honorable Alvin Thomas Embrey, who was one of the five judges picked to serve on the circuit court *c.* 1870. He was on the committee that helped bring the 31st reunion event of the Society of the Army of the Potomac to Fredericksburg in 1900, on the board of the Wallace Library, indexed the circuit court land records of the city and of Spotsylvania County, and was an official of the Fredericksburg Water Power Company. (Bill Beck, Beck's Antiques.)

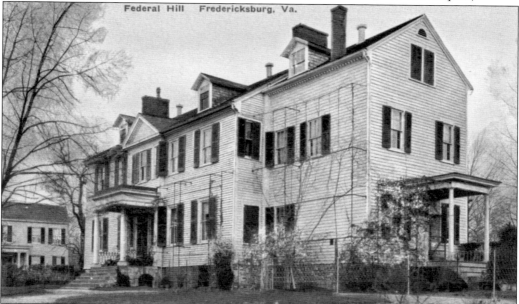

Federal Hill Fredericksburg, Va.

FEDERAL HILL. Robert Brooke, Virginia's leading anti–Federalist and supporter of state rights, built this building on Hanover Street in 1792. He was elected the third governor of the Commonwealth of Virginia, was a master mason at the Fredericksburg Masonic Lodge No. 4, and was elected attorney general of the Commonwealth of Virginia. The mansion was sold to Thomas Reade Rootes in 1801. Roots named his mansion on a hill opposing Marye's Heights "Federal Hill."

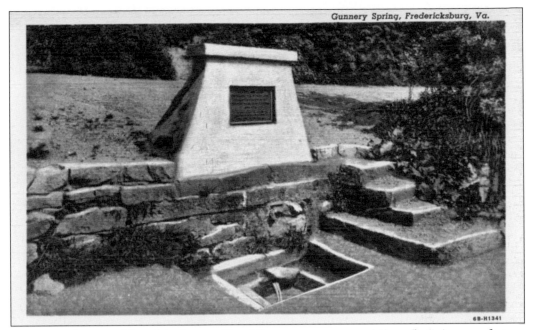

6B-H1341

GUNNERY SPRING. Near this place on Hazel Run, a gunnery, consisting of a main manufactory and a powder magazine, was established in 1775. It was managed by Charles Washington, brother of George Washington. Fielding Lewis was among the men who helped establish the gunnery, which made thousands of arms for the Continental Army. The state government and local residents financed the gunnery, which was marked by this stone monument and plaque. The plaque was later stolen.

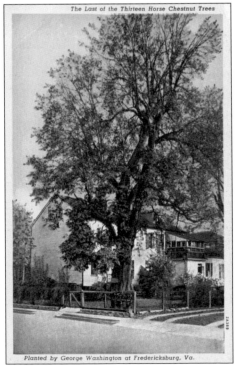

The Last of the Thirteen Horse Chestnut Trees

Planted by George Washington at Fredericksburg, Va.

HORSE CHESTNUT TREE. This horse chestnut tree, located on the 400 block of Fauquier Street, was the last of 13 planted by George Washington, who was said to have gathered the horse chestnuts in a garden in Philadelphia *c.* 1787. The 13 trees planted along Fauquier Street, which was the path from Washington's mother's home to his sister's home, were to represent the 13 original colonies. The city was forced to cut down this 217-year-old tree in August 2004 after attempts to save it failed.

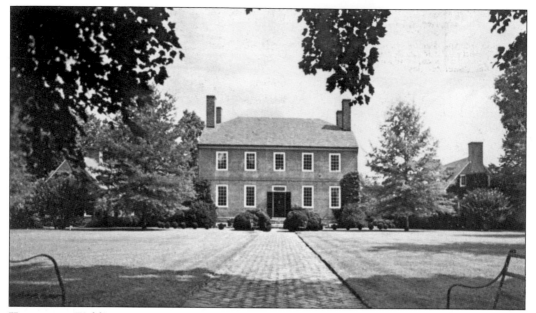

KENMORE. Fielding Lewis constructed this home on land that had been part of the Thornton-Lewis Patent for his bride, Betty, who was the only sister of George Washington. It is located at 1201 Washington Avenue. It was built just before the American Revolution. Lewis was one of the managers of the Gunnery, which supplied arms for the Revolutionary War. He also owned ships important in the Revolutionary War. The *Dragon*, built in Fredericksburg, was used to patrol the Rappahannock River and parts of the Chesapeake Bay. Samuel Gordon purchased the house and the land immediately surrounding it and named it Kenmore. It has recently undergone extensive restoration. The postcard below shows the bedroom Mary Ball Washington used when she visited her daughter at Kenmore.

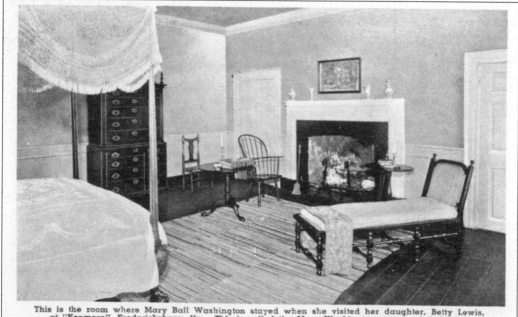

This is the room where Mary Ball Washington stayed when she visited her daughter, Betty Lewis, at "Kenmore", Fredericksburg, Va. This is called the Mary Washington room and dedicated to Michigan the State from which the first Dollar came to Kenmore

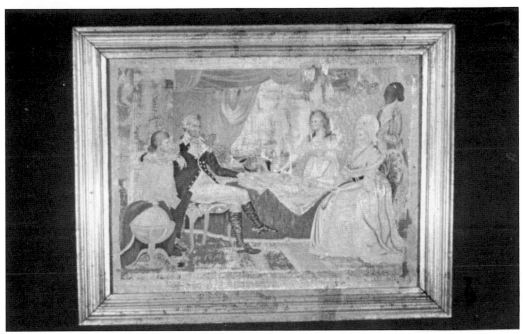

KENMORE CREWEL. This crewel-work picture of the Washington family was made by Betty Washington Lewis and her sister-in-law, Martha Washington. It is owned by the George Washington Fredericksburg Foundation.

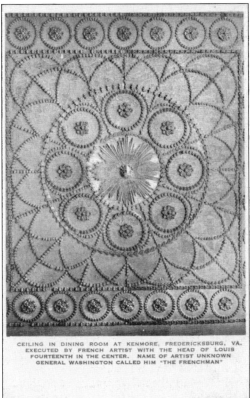

CEILING IN DINING ROOM AT KENMORE, FREDERICKSBURG, VA. EXECUTED BY FRENCH ARTIST WITH THE HEAD OF LOUIS FOURTEENTH IN THE CENTER. NAME OF ARTIST UNKNOWN GENERAL WASHINGTON CALLED HIM "THE FRENCHMAN"

KENMORE'S DINING ROOM CEILING. A number of the rooms in Kenmore have intricate and extensive decorative plasterwork created by a French artisan. Plantation records tell us only that George Washington referred to him as "the Frenchman" and sent him to Kenmore. The center design of the dining room ceiling is the head of Louis IV.

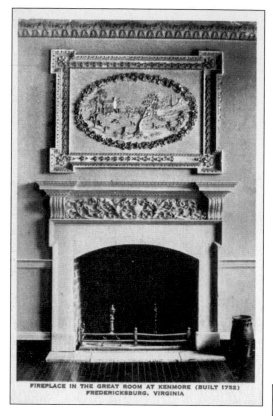

FIREPLACE IN THE GREAT ROOM AT KENMORE (BUILT 1752)
FREDERICKSBURG, VIRGINIA

KENMORE'S GREAT ROOM OVER-MANTEL. This postcard states that the stucco over the mantel was designed by Gen. George Washington and represents the Aesop fable of the fox, the crow, and the piece of cheese to teach his nephews to beware of flatterers. The Frenchman carried out this artistic concept.

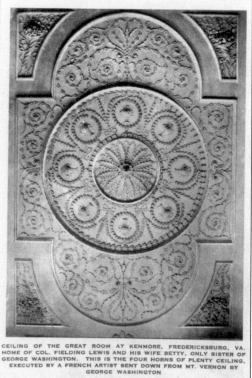

CEILING OF THE GREAT ROOM AT KENMORE, FREDERICKSBURG, VA.
HOME OF COL. FIELDING LEWIS AND HIS WIFE BETTY, ONLY SISTER OF
GEORGE WASHINGTON. THIS IS THE FOUR HORNS OF PLENTY CEILING,
EXECUTED BY A FRENCH ARTIST SENT DOWN FROM MT. VERNON BY
GEORGE WASHINGTON

KENMORE'S GREAT ROOM CEILING. Also called the drawing room, it is decorated with beautiful plasterwork created by an unknown plasterer referred to in plantation records as "the Frenchman." George Washington sent him to his sister, Betty, and her husband, Col. Fielding Lewis. The plasterwork designs on the ceiling are of the four horns of plenty. The publication *The 100 Most Beautiful Rooms in America* included two rooms at Kenmore.

78

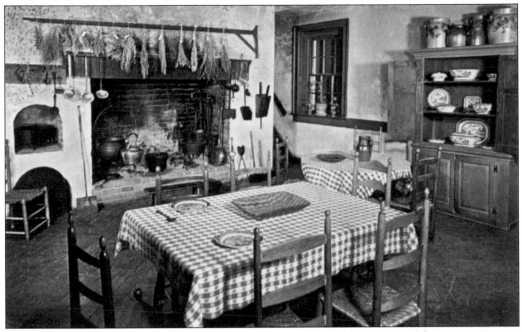

KENMORE'S KITCHEN. The kitchen shown in this postcard was built on its original foundation. For many years, visitors were treated to tea and gingerbread made from the personal recipe of Mary Washington, mother of the first president.

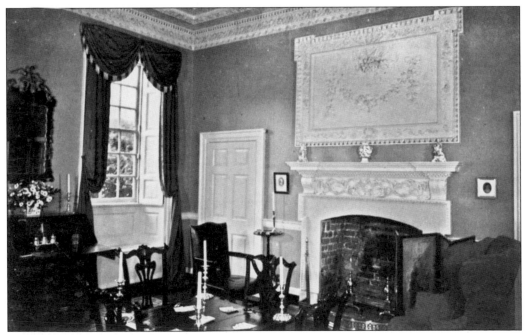

KENMORE'S LIBRARY. The library at Kenmore also has beautiful plasterwork by the Frenchman on the ceiling and on the fireplace over-mantel.

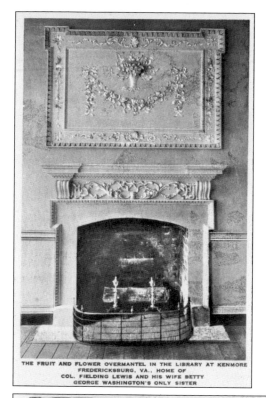

KENMORE'S LIBRARY OVER-MANTEL.
The plaster decoration in the over-mantel at Kenmore is of fruit and flowers. As was the other decorative plasterwork at Kenmore, it was done by George Washington's plasterer, known only as the Frenchman.

THE FRUIT AND FLOWER OVERMANTEL IN THE LIBRARY AT KENMORE
FREDERICKSBURG, VA., HOME OF
COL. FIELDING LEWIS AND HIS WIFE BETTY
GEORGE WASHINGTON'S ONLY SISTER

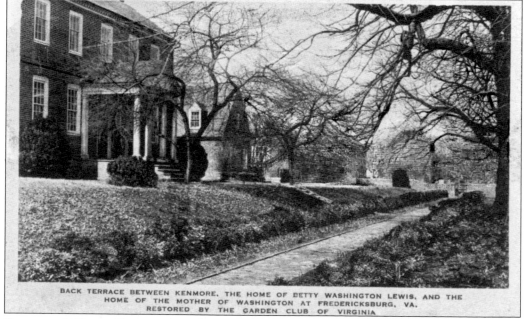

BACK TERRACE BETWEEN KENMORE, THE HOME OF BETTY WASHINGTON LEWIS, AND THE
HOME OF THE MOTHER OF WASHINGTON AT FREDERICKSBURG, VA.
RESTORED BY THE GARDEN CLUB OF VIRGINIA

KENMORE'S REAR ENTRANCE. The gardens at Kenmore were restored in 1929 through the efforts of the Garden Club of Virginia, which raised funds for the restoration. From this effort, Historic Garden Week in Virginia was born. Beginning in 1992, the Garden Club of Virginia undertook another extensive redesigning and replanting of Kenmore's gardens. Kenmore is a National and Virginia Historic Landmark.

KENMORE SALON. This postcard view of the salon at Kenmore shows Betty Washington Lewis's fireside chair and desk. Above the desk is the original *c.* 1770 portrait of Fielding Lewis by artist John Wollaston. Beautiful plasterwork can be seen adorning the ceiling.

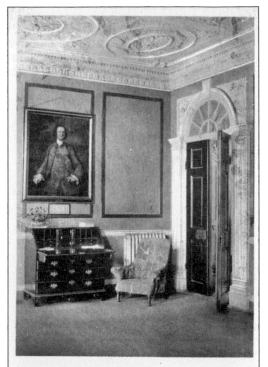

ORIGINAL PORTRAIT OF FIELDING LEWIS BY JOHN WOLLASTON, ARTIST, ABOUT 1770. BETTY WASHINGTON LEWIS' OWN FIRESIDE CHAIR AND DESK IN THE SALON AT KENMORE, FREDERICKSBURG, VA.

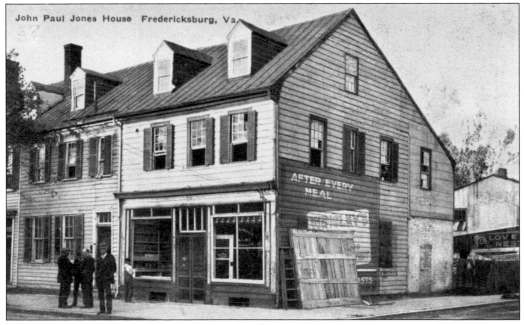

John Paul Jones House Fredericksburg, Va.

JOHN PAUL JONES. This house, located at 501 Caroline Street, belonged to Jones's brother, William Paul. Adm. John Paul Jones, the famous naval officer of the American Revolutionary War, lived in Fredericksburg from 1773 to 1775. In the 1880s, this building was the home of M. J. Gately Groceries.

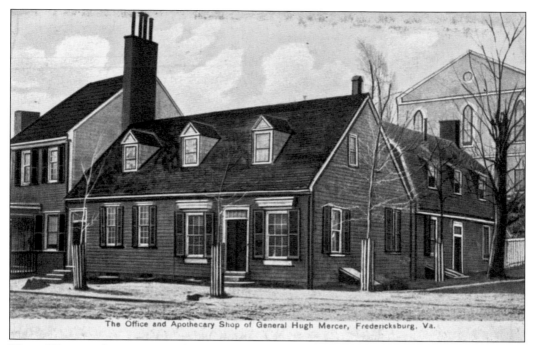

The Office and Apothecary Shop of General Hugh Mercer, Fredericksburg, Va.

HUGH MERCER APOTHECARY SHOP. Dr. Hugh Mercer, a Scotchman and physician, served with George Washington in the French and Indian War. Mercer moved to Fredericksburg, where he married Isabella Gordon, daughter of John Gordon and sister of Mrs. George Weedon. He was one of the seven generals Fredericksburg gave to the American Revolution. This 18th-century property is owned by APVA Preservation.

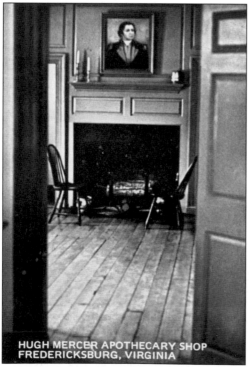

HUGH MERCER APOTHECARY SHOP
FREDERICKSBURG, VIRGINIA

HUGH MERCER APOTHECARY SHOP INTERIOR. The interior of the Hugh Mercer Apothecary Shop is decorated to represent an 18th-century pharmacy and doctor's office. The living history presentations show the surgical procedures and medicines used in the period. Amputations, the removal of boils, bloodletting, tooth pulling, and the removal of cataracts attempted by Dr. Mercer are described. The use of medicines and medical techniques, such as silver-coated pills and leeches, is also described.

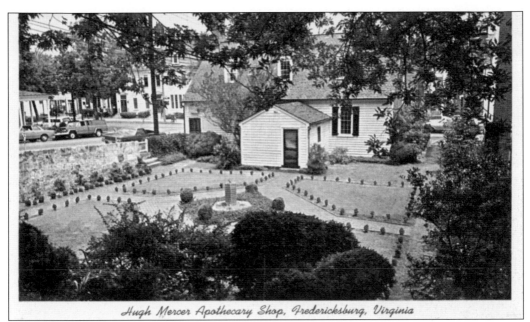

Hugh Mercer Apothecary Shop, Fredericksburg, Virginia

HUGH MERCER APOTHECARY SHOP GARDEN. After moving to Fredericksburg, Hugh Mercer practiced medicine and operated an apothecary shop. Herbs and roots were used to treat ailments in the Colonial days as their products are today. Mary Ball Washington visited Mercer's apothecary for toddies on several occasions. Mercer closed his apothecary shop to enter the Continental Army to command the 3rd Regiment of Fredericksburg and fight in the American Revolutionary War.

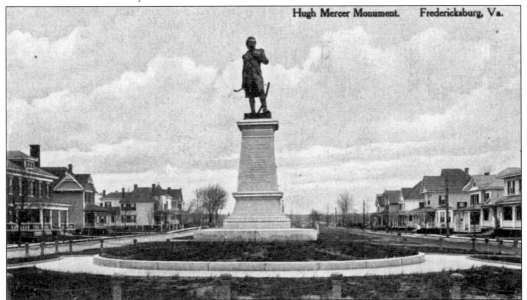

Hugh Mercer Monument. Fredericksburg, Va.

STATUE OF GENERAL MERCER. Edward Valentine of Richmond, who made the reclining statue of Robert E. Lee at Washington and Lee University, sculpted the Hugh Mercer statue, which is located on Washington Avenue. The statue was erected in 1906 by the federal government. Mercer became a general in the Revolutionary War. He was killed at the Battle of Princeton in 1777. Gen. George S. Patton (World War II) was a great-great-great-grandson of General Mercer.

83

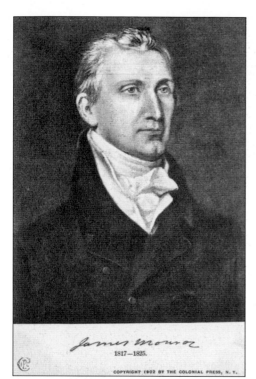

JAMES MONROE PORTRAIT. Monroe, born in 1758 in Westmoreland County, served in the American Revolution with Gen. George Washington and was wounded at the Battle of Trenton. He returned to the College of William and Mary where he studied law in Thomas Jefferson's office. Monroe served in the Confederation Congress, as governor of Virginia, as secretary of war, and two terms as president. He helped negotiate the Louisiana Purchase. He was later a member of the Society of the Cincinnati, membership of which was made up of officers serving under Washington in the Revolutionary War.

James Monroe
1817–1825.

COPYRIGHT 1902 BY THE COLONIAL PRESS, N. Y.

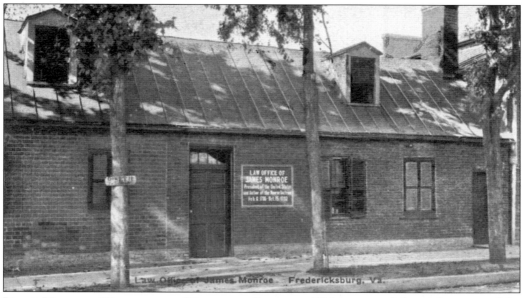

Law Office of James Monroe. Fredericksburg, Va.

JAMES MONROE MUSEUM AND MEMORIAL LIBRARY. This museum is located on part of the original corner lot that fronted on Charles and William Streets, which James Monroe purchased in 1786. Rose Gouverneur Hoes and her two sons established the museum in the structure that was on the lot in 1927. The museum has over 10,000 books as well as the Ingrid Westesson Hoes Archives that contain over 27,000 historical documents. Laurence Hoes continued to develop the museum from 1927 until his death in 1978. The collection also includes many personal possessions of the Monroes, including jewelry, gowns and other clothing, silver, china, porcelain, and more. The University of Mary Washington administers the museum.

JAMES MONROE PORTRAIT BY REMBRANDT PEALE. This portrait of Pres. James Monroe was painted by Rembrandt Peale in the White House, 1817–1825. This postcard shows it hanging in the niche of the gallery in the wing added to the James Monroe Museum and Memorial Library. Monroe married Elizabeth Kortright of New York. They moved to Fredericksburg in 1786, where he practiced law and where their first child was born. In 1789, they moved to Albemarle County.

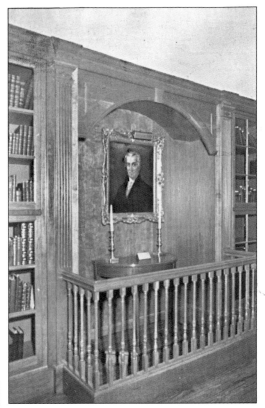

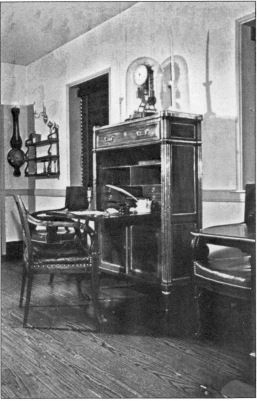

JAMES MONROE DESK. Monroe used this Louis XVI–style desk when he signed the Monroe Doctrine in the White House as the fifth president of the United States. This desk, purchased during Monroe's diplomatic service in France, is just one piece in an extensive collection at the James Monroe Museum and Memorial Library.

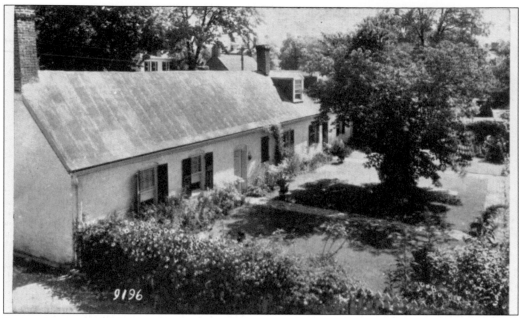

JAMES MONROE MUSEUM GARDENS. This postcard shows the James Monroe Museum and Memorial Library building before the addition was constructed. The garden contains plants and shrubs from the Colonial period. The garden has been maintained by local garden clubs and volunteers. The walled garden is the last unimproved real estate on a lot, which originally was a quarter of the complete city block. Monroe's original lot had half its road frontage on Charles Street and the other half on William Street.

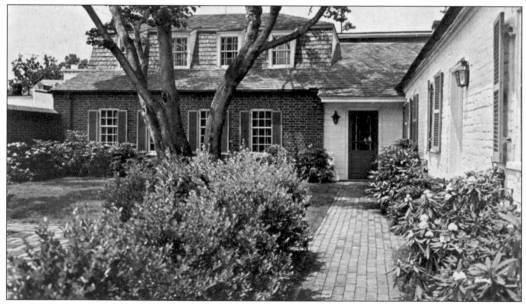

JAMES MONROE MUSEUM ADDITION. The structure shown in this postcard is the addition to the rear of the James Monroe Museum and Memorial Library. It houses thousands of volumes and manuscripts relating to James Monroe and the Monroe Doctrine, a gift shop, and administrative offices on the second floor. This lot is all that remains intact of the corner lot that fronted on Charles and William Streets when James Monroe purchased it in 1786.

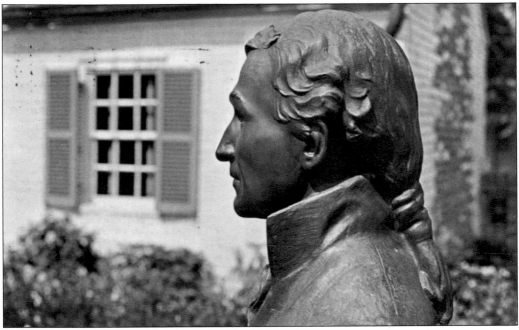

JAMES MONROE BUST. This bust of James Monroe, by American sculptress Margaret French Cresson, is in the rear of the James Monroe Museum and Memorial Library.

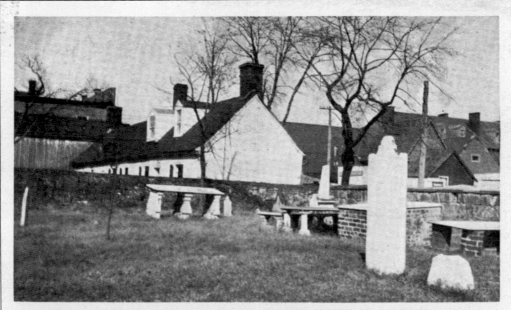

LAW OFFICE OF JAMES MONROE FROM HISTORIC MASONIC GRAVEYARD, FREDERICKSBURG, VA.

JAMES MONROE MUSEUM AND MASONIC GRAVEYARD. The James Monroe Museum and Memorial Library is west of the Masonic Graveyard on Charles Street. Christiana Campbell, keeper of the tavern known by her name in Williamsburg; Robert Lewis, son of Fielding and Betty Washington Lewis of Kenmore and private secretary of his uncle, Pres. George Washington; Lewis Littlepage, aid to John Jay when he was minister to Spain; and George Weedon, Revolutionary general, are a few of the people buried in the Masonic cemetery.

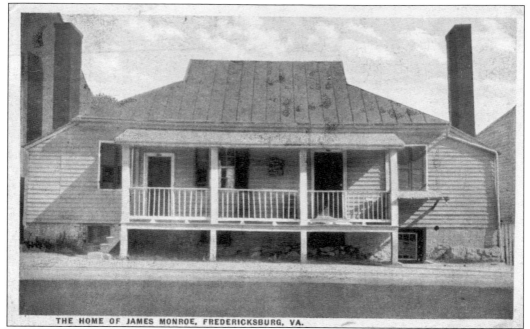

THE HOME OF JAMES MONROE, FREDERICKSBURG, VA.

HOME OF JAMES MONROE. This postcard incorrectly identified this structure as the home of James Monroe. When he lived in Fredericksburg, Monroe and his wife lived in the home of his maternal uncle, Judge Joseph Jones, located at 301 Caroline Street. This building was located on Princess Anne Street before it was razed during the Depression.

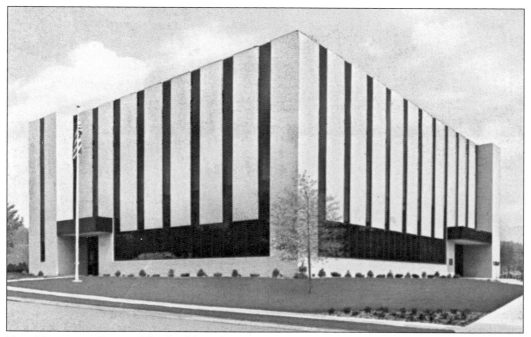

THE NATIONAL BANK. This building, located at 2403 Fall Hill Avenue, opened in 1975. Sidney E. King of Caroline County, who was a muralist for the National Park Service and portrait artist, painted scenes from Fredericksburg's history in the lobby of this National Bank building.

NICK'S TAILOR SHOP. For over 40 years beginning in the middle of the 1900s, Nick Lapomo served the Fredericksburg community as a tailor at this location at 900½ Caroline Street. His shop was on the second floor of the building serviced by an exterior iron staircase on the 200 block of George Street. Nick the tailor was much beloved in the community. (Bill Beck, Beck's Antiques.)

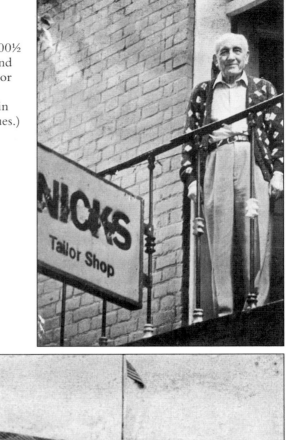

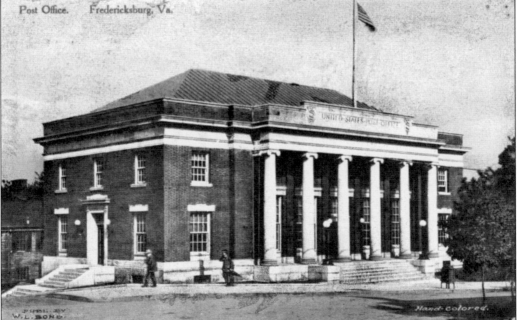

POST OFFICE. The first main post road stretched from Maine to Georgia running through Fredericksburg, which was considered the gateway to the South. Mail passed through the Fredericksburg office, which was also on the route from New York to New Orleans. The mail was forwarded by stage and post-riders to points north and south and east and west, as well as all around the city's environs. Seven mail routes emanated from the local post office by 1810. By 1820, mail sorting and distribution to five states occurred here.

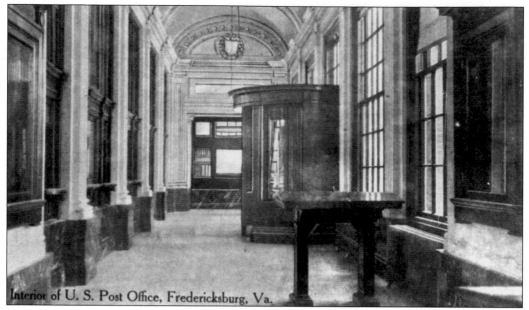

Interior of U. S. Post Office, Fredericksburg, Va.

POST OFFICE INTERIOR. The early post office was located in the home of Reuben T. Thom until it burned, along with many other town residences, as a result of the hot shot fired from Chatham during the First Battle of Fredericksburg. This post office is now used by the City of Fredericksburg as the city hall. A new post office was built in the 600 block of Princess Anne Street in the 1970s.

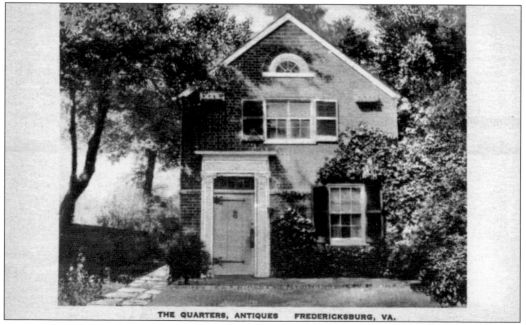

THE QUARTERS, ANTIQUES FREDERICKSBURG, VA.

THE QUARTERS ANTIQUE SHOP. This building still stands at 305 Amelia Street. It is part of the Doggett House property. Dr. Andrew C. Doggett, who acquired the property from his father, left the property to his daughter, Kate Newell Doggett Boggs. Kate ran the Quarters Antique Shop from this brick building. (Gari Melchers Home and Studio, University of Mary Washington, Fredericksburg, Virginia.)

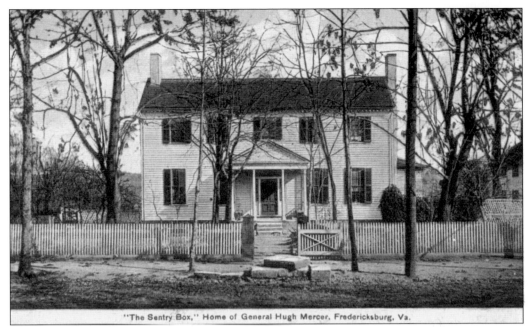

"The Sentry Box," Home of General Hugh Mercer, Fredericksburg, Va.

SENTRY BOX. This was the home of Gen. George Weedon and his wife, Catherine Gordon, daughter of John Gordon, who was a tavern proprietor in Fredericksburg. Weedon was one of the seven generals Fredericksburg gave to the American Revolution. Weedon built the Sentry Box at 133 Caroline Street for his residence after having bought lots on lower Caroline Street in partnership with his brother-in-law, Hugh Mercer, *c.* 1764. The Sentry Box is now the home of Charles G. McDaniel and his wife, Mary Wynn.

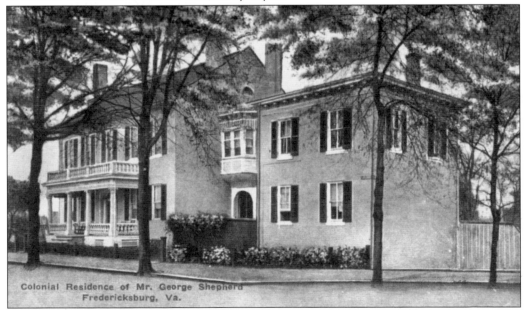

Colonial Residence of Mr. George Shepherd
Fredericksburg, Va.

GEORGE SHEPHERD COLONIAL RESIDENCE. The Shepherd House, located on the north corner of Princess Anne and Lewis Streets, was built after the home of its original owner, Mr. Stannard, burned in October 1807. Shepherd was one of the commanders of the Confederate Veterans of Fredericksburg, which began in 1883. It is now the home of Dr. and Mrs. Robert Wheeler.

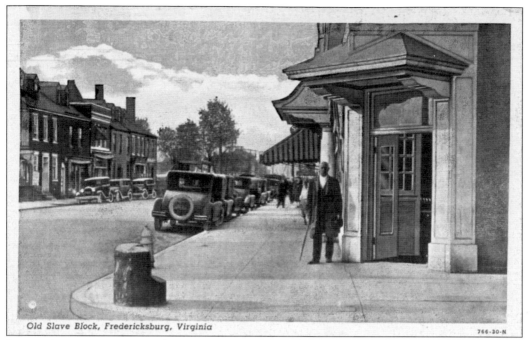

Old Slave Block, Fredericksburg, Virginia

766-30-N

SLAVE AUCTION BLOCK. This postcard and the next are of the slave auction block located at the corner of William and Charles Streets. The postcards state that the man standing nearby is Albert Crutchfield, who was sold from the block about 1859 when he was about 15 years old. Note that these cards are nearly the same except for the cars, which are from two different times. This shows how postcard images can be manipulated and care must be taken when using a card for dating or identification purposes.

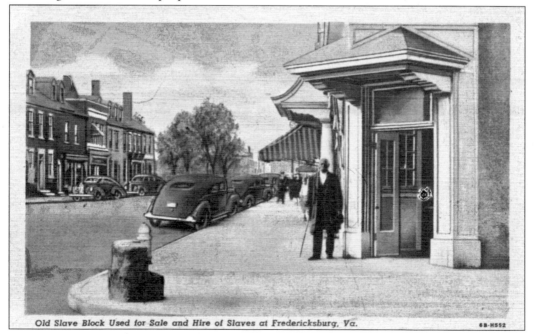

Old Slave Block Used for Sale and Hire of Slaves at Fredericksburg, Va.

6B-H552

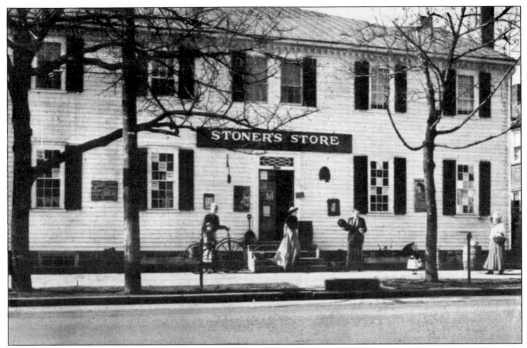

STONER'S STORE MUSEUM. The building that housed Stoner's Store Museum was formerly the Chew House. This museum contained presses, general store fixtures, household and farm machines, and more. Stoner also owned Fredericksburg Hardware Company along with his brother-in-law Charles D. Binns and H. M. Janney Jr.

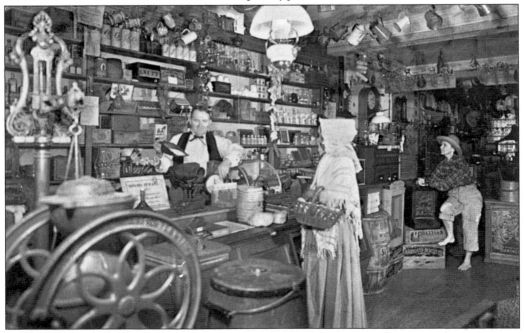

STONER'S STORE MUSEUM INTERIOR. The museum looked much like the general stores of the 19th century and contained hand–operated vacuum cleaners, toys, butter churns, food, and accessories. The *c.* 1815 building had previously housed part of the Fredericksburg College.

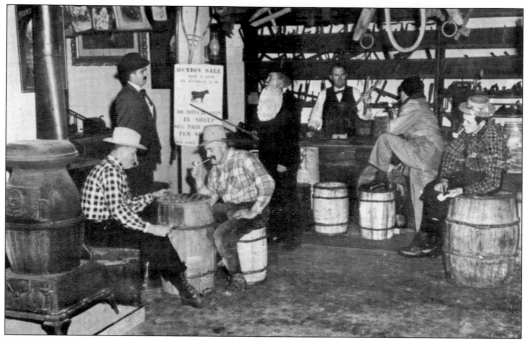

STONER'S STORE MUSEUM INTERIOR WITH MEN. This postcard shows men smoking, playing checkers, buying farm supplies, and most importantly, talking. Much of the news of the day was passed along in country stores like this. Brothers Paul and David Scott sold Civil War minié balls by the hundreds at 7¢ apiece when they were boys in the 1950s. They found the minié balls in the nearby Civil War campsites and battlefields.

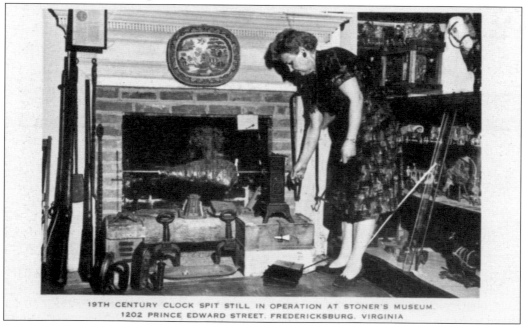

STONER'S STORE MUSEUM CLOCK SPIT. A woman is shown using a 19th-century clock spit, which was still in operation at Stoner's Museum. The museum had murals depicting local history painted by Sidney E. King around the wall of the store. This postcard dates to the 1950s.

STONER'S STORE MUSEUM POST OFFICE. Many country stores offered multiple services to the public. This postcard shows a post office in operation in the store as well as the selling of household and farm goods.

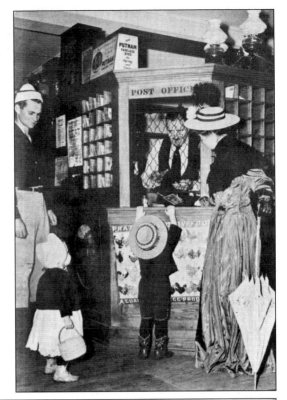

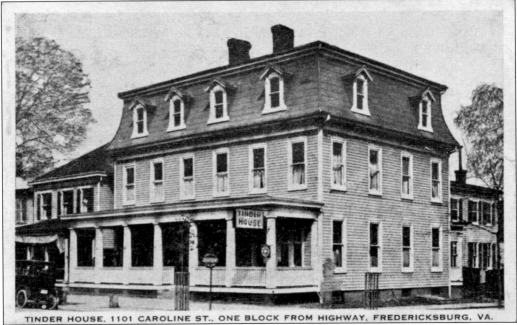

TINDER HOUSE, 1101 CAROLINE ST., ONE BLOCK FROM HIGHWAY, FREDERICKSBURG, VA.

TINDER HOUSE. During the 1940s and 1950s, this building was called the Professional Building. Prominent physicians at the time—Dr. Lloyd Busch, who owned the building; Dr. D. William Scott Jr., an internist; Dr. L. Philip Cox, an eye, ear, nose, and throat specialist; and Dr. Gordon Jones, an ob–gyn—had their offices here.

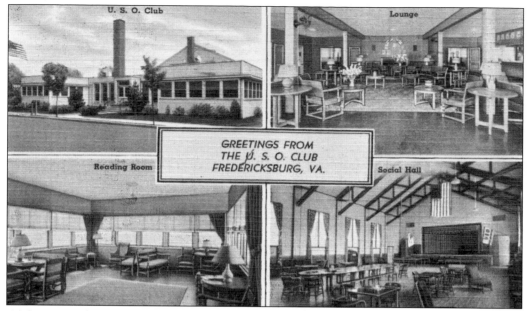

USO Club. The national United Service Organization was formed in 1941 to serve the religious, spiritual, and educational needs of the men and women in the armed forces during World War II. USO Clubs sponsored many activities for service personnel including dances, dinners, and sporting events. The Fredericksburg USO Club was located at the corner of Canal and Charles Streets. Today the building houses the Fredericksburg Community Center.

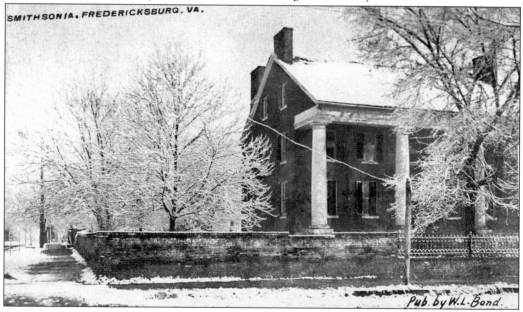

Smithsonia. This home at 307 Amelia Street, built *c.* 1834, was used as the boy's dormitory for the Fredericksburg College. The college was founded in 1893 by the Reverend Dr. A. P. Saunders, a Presbyterian missionary. Its original name, Collegiate Institute, was changed to Fredericksburg College in 1897. Smithsonia was for many years the residence of Dr. Earl R. Ware and his wife, Jane. (Courtesy of the Gari Melchers Home and Studio, University of Mary Washington, Fredericksburg, Virginia.)

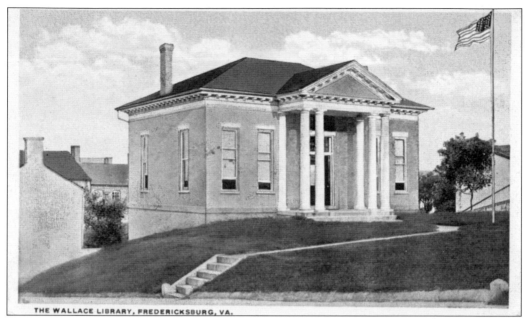

THE WALLACE LIBRARY, FREDERICKSBURG, VA.

WALLACE LIBRARY. This library was named for Capt. C. Wistar Wallace, CSA, a native of Fredericksburg who left a bequest of $15,000 for a public library to be named for him. The two-story library building with a basement was constructed on the courthouse lot at 817 Princess Anne Street, where it still stands. It now houses the Fredericksburg School Board Administrative offices.

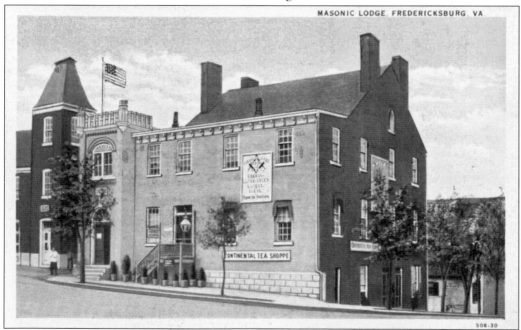

MASONIC LODGE, FREDERICKSBURG, VA.

508-30

GEORGE WASHINGTON'S MASONIC LODGE. The Masonic Lodge, located at the corner of Princess Anne and Hanover Streets, exhibits memorabilia about George Washington, its most famous member. The lodge began in 1752. George Washington was made a Mason in and by this lodge. Lafayette became a member in 1824. Hugh Mercer was also a member. The Continental Tea Shoppe was located in the basement on the Hanover Street side around 1935.

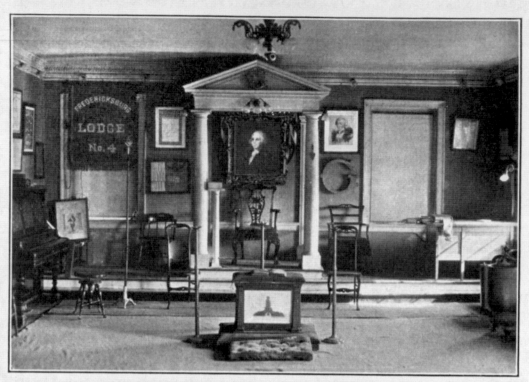

WASHINGTON'S MOTHER LODGE

WASHINGTON MOTHER LODGE INTERIOR. The original Gilbert Stuart portrait of the first president hangs here. The present Masonic Lodge building was built around 1814.

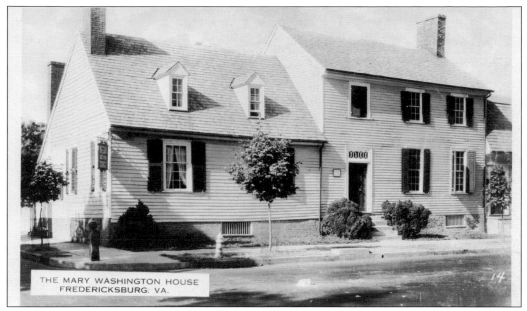

MARY WASHINGTON HOUSE. This house at 1200 Charles Street was the home of George Washington's mother, Mary Ball Washington, who was born at Epping Forest in Lancaster County, Virginia, in 1708. She married Capt. Augustine Washington on March 6, 1731. They became the parents of George, Samuel, John Augustine, Charles, Betty, and Mildred. Mary Washington moved from Ferry Farm to this house in Fredericksburg in 1772. This pre-1772 property is owned by APVA Preservation.

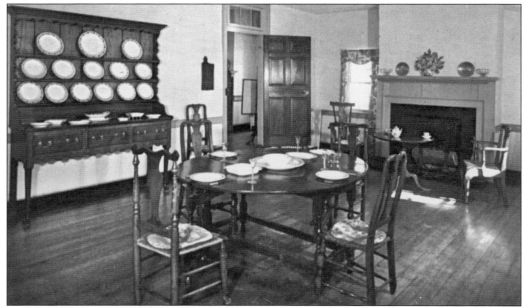

MARY WASHINGTON HOUSE DINING ROOM. Mary lived here the last 17 years of her life from 1772 until her death in 1789. It is the only house in which Mary lived that still stands. This house is where George Washington came to visit and say his last farewell to his mother. In the past, during garden week, there was a live reenactment of Washington's farewell to his mother. Attending tourists loved it.

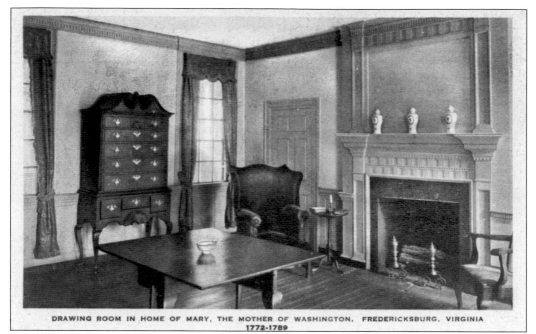

DRAWING ROOM IN HOME OF MARY, THE MOTHER OF WASHINGTON, FREDERICKSBURG, VIRGINIA
1772-1789

MARY WASHINGTON HOUSE DRAWING ROOM. Mary Washington received Lafayette here in 1924 on his tour of the United States after the Revolutionary War. George Washington bought this home for his mother.

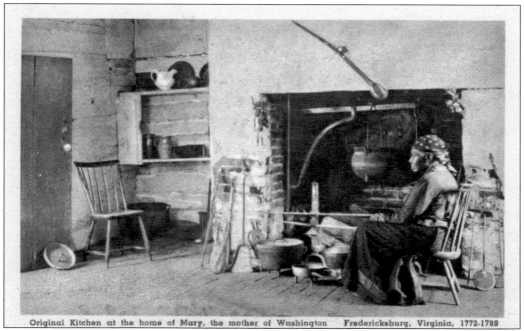

Original Kitchen at the home of Mary, the mother of Washington Fredericksburg, Virginia, 1772-1789

MARY WASHINGTON HOUSE COLONIAL KITCHEN INTERIOR. The original kitchen with its slave quarters stands behind the house. Some of Mary Washington's slaves were willed to relatives. The APVA Preservation Virginia acquired this property in 1890.

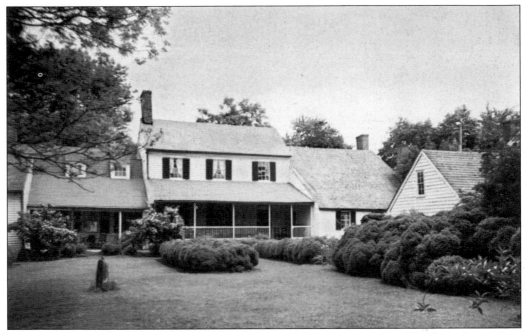

MARY WASHINGTON HOUSE COLONIAL KITCHEN AND GARDENS. The lot where Mary Washington's home is located was part of the Thornton-Lewis Patent. The boxwood Mary Ball Washington planted still grows here. Her daughter, Betty Washington Lewis, lived a short walk away at Kenmore.

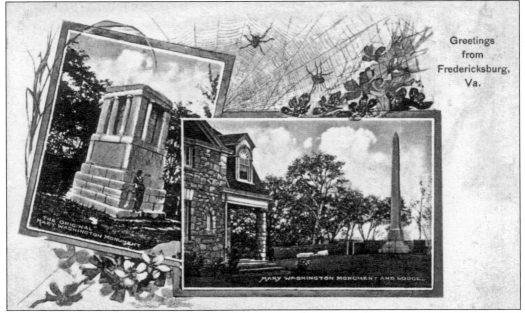

MARY WASHINGTON MONUMENT. This early postcard shows the original Mary Washington Monument before and after it was finished and the caretaker's cottage. In 1833, Silas Burrows, a wealthy New York merchant, agreed to pay for a monument for Mary Washington's grave. Pres. Andrew Jackson was present when the Fredericksburg Masonic Lodge laid the cornerstone for the monument in May 1833. Financial reverses prevented Burrows from finishing the monument.

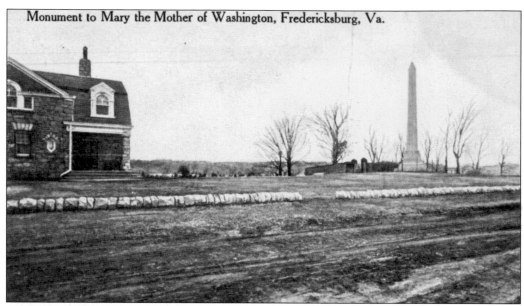

Monument to Mary the Mother of Washington, Fredericksburg, Va.

MARY WASHINGTON MONUMENT MUSEUM AND CARETAKER'S HOME. The first residents of the "Caretaker's Lodge" were Judge and Mrs. John T. Goolrick. Mrs. Goolrick was custodian of the lodge. In 1966, this property and the adjoining Mary Washington Monument were deeded to the City of Fredericksburg.

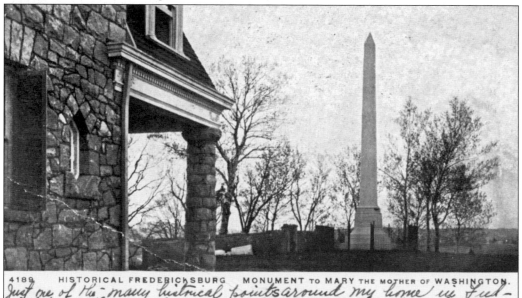

4189 HISTORICAL FREDERICKSBURG MONUMENT TO MARY THE MOTHER OF WASHINGTON.

Just one of the many historical points around my home in Fredericksburg — Enjoyed your epistle very much will write soon — Why not send me some postals of Baltimore? Sincerely M.C.M.

MARY WASHINGTON MONUMENT MUSEUM AND CARETAKER'S HOME. Since 1979, the Kenmore Association has leased this building from the city. Romanesque, Queen Anne, Victorian, and Colonial elements used in the design reflect the great American architect H. H. Richardson and the firm of McKim, Mead and White. The lodge was built with local granite and red mortar. The use of colored mortars was popular in the period around 1900. The area was sparsely populated at the time these images were captured.

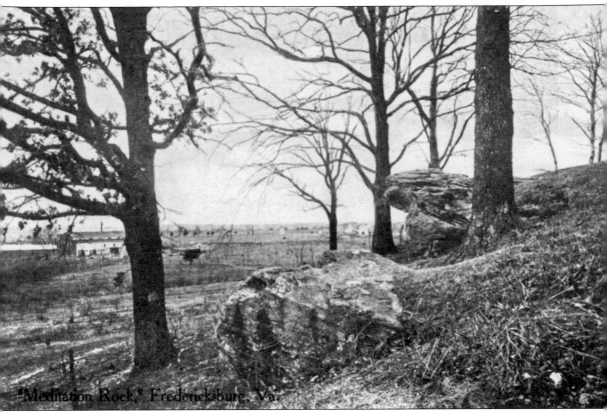

"Meditation Rock," Fredericksburg, Va.

MEDITATION ROCK. Mary Ball Washington often came to this spot to meditate and to pray. She most surely prayed for the safety of her son and her country in the years leading to and during the American Revolution. This spot must have been important to her because she requested that she be buried here. Mary Washington died in 1789, and her grave went unmarked for many years. Today there is a small, gated cemetery nearby where she is buried.

Mary Washington Grave & Meditation Rock, Fredericksburg, Virginia

MARY WASHINGTON MONUMENT AND MEDITATION ROCK. Mary Ball Washington died August 25, 1789, and was buried at Meditation Rock four days later. In 1889, the centennial year of Mary Washington's death, a group was chartered with the goal of erecting a new monument. The National Mary Washington Memorial Association erected the present monument. The monument was dedicated on May 10, 1894. Pres. Grover Cleveland was the honored guest and main speaker. Vice Pres. Adlai E. Stevenson, the governor of Virginia, and others were present.

Seven

Taverns and Restaurants

COLONIAL ROOM. This dining room was in the General Washington Inn. The postcard states, "The latch string is always out. . . . Come and enjoy delicious meals in a truly Colonial setting. Superb food plus reasonable prices have made the Inn one of the outstanding eating places in Northern Virginia. General Washington Inn in Fredericksburg, Virginia's most historic city." For many years prior, the General Washington Inn had been the Stratford Hotel (see chapter eight).

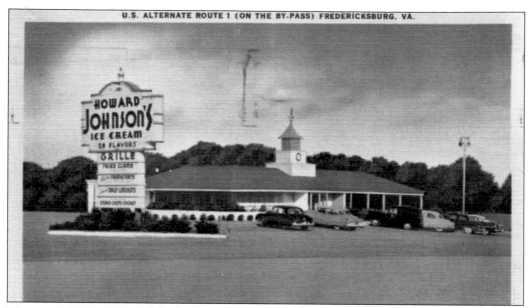

HOWARD JOHNSON'S. This restaurant was located on U.S. Route 1 (known locally as "the Bypass") near present–day Park and Shop Shopping Center. It later became Hamway's Restaurant. It was torn down in the 1960s. This postcard advertised Howard Johnson's Restaurant as "Air conditioned—Ample parking. Opposite Mary Washington College. George Washington Motor Court 2 blocks south."

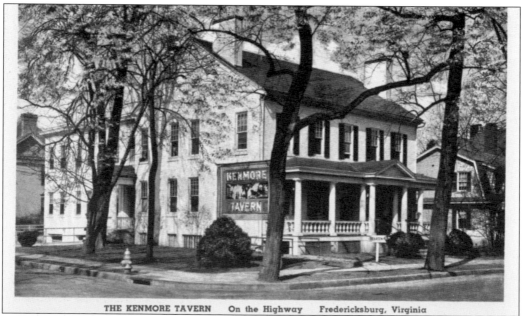

THE KENMORE TAVERN On the Highway Fredericksburg, Virginia

KENMORE TAVERN. This building, which housed the Kenmore Tavern, is located at 1200 Princess Anne Street. It became the Kenmore Lodge with the Kenmore Coffee Shop in the basement. This postcard states, "Situated in the midst of the historical center of Fredericksburg, within one block of the home of Mary Washington. 'Kenmore' is only three blocks, and other places in walking distance. Every room is an outside room, and an attractive restaurant is on the first floor." It is now the Kenmore Inn.

OCCIDENTAL RESTAURANT. This postcard advertised the Occidental Restaurant as the "Most Modern in Fredericksburg—Specializing in Sea Food, Steak, Virginia Ham and Chicken Dinner, 1009 Princess Anne Street . . . Phone 9139." This structure now houses Apple Music.

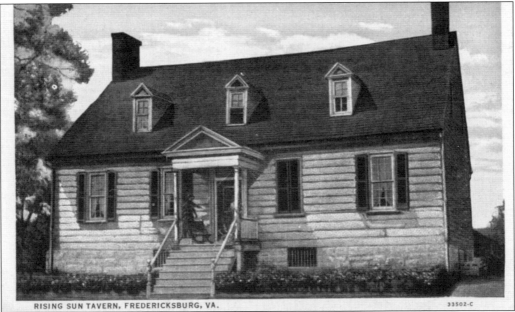

RISING SUN TAVERN. This historic building at 1304 Caroline Street is a tourist attraction. It was built as a home by Charles Washington, youngest brother of George Washington, *c.* 1760. The house was leased to John Frazier, who opened the Golden Eagle Tavern in the former home. It was also known as the Eagle Tavern before being named the Rising Sun Tavern in 1821. The building had become a residence again by 1827. This *c.* 1760 property is owned by APVA Preservation.

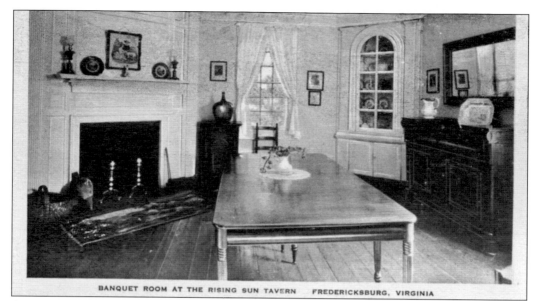

BANQUET ROOM AT THE RISING SUN TAVERN FREDERICKSBURG, VIRGINIA

RISING SUN TAVERN BANQUET ROOM. Restorations were made to return this building to its 18th-century tavern appearance. The front porch was reconstructed, and sections of the old bar were discovered and reassembled into the taproom bar complete with a collection of early pewter. The tavern was host to many Revolutionary War notables including George Washington, Thomas Jefferson, Patrick Henry, and George Mason.

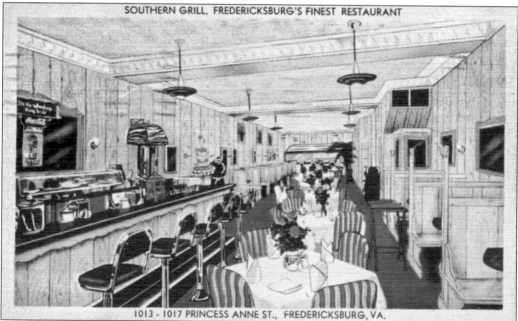

SOUTHERN GRILL, FREDERICKSBURG'S FINEST RESTAURANT

1013 - 1017 PRINCESS ANNE ST., FREDERICKSBURG, VA.

THE SOUTHERN GRILL RESTAURANT. F. A. Soret was the proprietor of the Southern Grill Restaurant, which was located at 1013–1017 Princess Anne Street. This postcard advertised genuine Virginia hams packed in the famous "Ole Virginny Recipe since 1840." A "Colonel Sanders"–type character pictured on the back states, "Welcome to the Southern Grill, southern home cooking—we specialize in sea food." The Fredericksburg Baptist Church later purchased this property as part of its expansion.

Eight

Tourist Homes, Inns, Hotels, and Motels

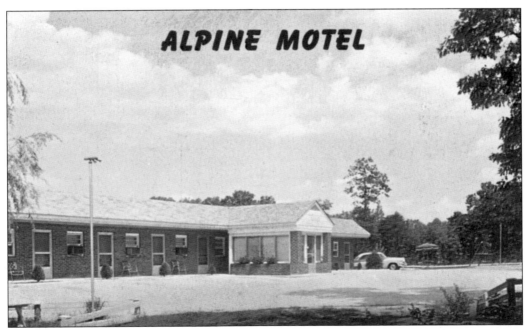

ALPINE MOTEL. The building that housed the Alpine Motel is still located on Jefferson Davis Highway. This postcard advertised "New & Modern—Tub & Shower—Hot Water Heat—Air-Conditioning—and Television—Owned and Operated by Mr. & Mrs. G. Christiansen." It was at 3301 Jefferson Davis Boulevard, Fredericksburg, Virginia, a mile and a half south of Howard Johnson's.

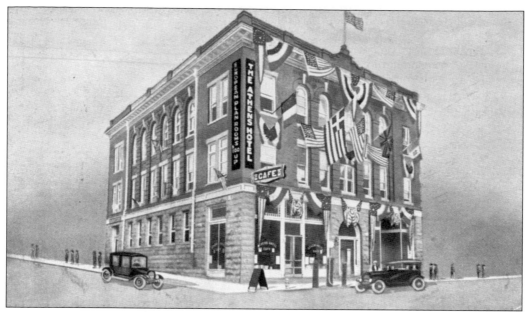

ATHENS HOTEL. This hotel was located in the building at the corner of Caroline and Hanover Streets. John Pappandreou was the proprietor. This postcard advertised, "European Plan Rooms $1.00 up." For many years in the mid-1900s, it housed White and Weeks Furniture Store. It is now occupied by gift and specialty shops.

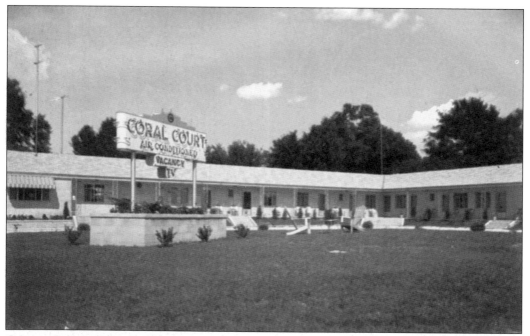

CORAL COURT. This small motel was located at "1210 Snowden Street, U.S. Highway No. 1, Fredericksburg, Va. (Opposite Howard Johnson's Restaurant) New and Completely Modern, with Tub and Showers, Hot Water Heat. Air Conditioned and TV. Located in Virginia's Most Historic City. . . . Owned and Operated by Mr. and Mrs. O. T. Payne." The building still stands next to the College Heights McDonald's and is presently used as an Emergency Animal Clinic.

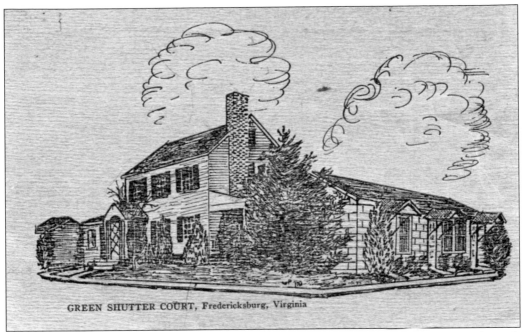

GREEN SHUTTER COURT, Fredericksburg, Virginia

GREEN SHUTTER COURT. This motel advertised its location as being "on U.S. 1 through Fredericksburg, 2½ miles south of town. Attractive rooms, quiet location, hot water heat, private baths. Restaurant nearby. Moderate rates. . . . M. F. E. Chandler."

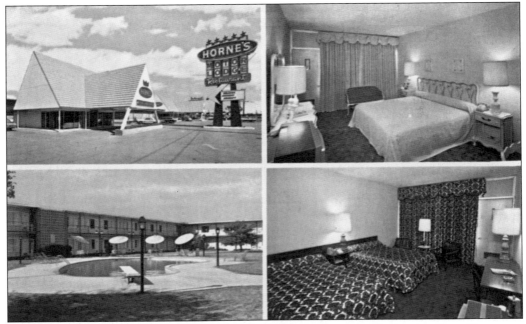

THE HORNE'S MOTOR LODGE. This motel building was located at the intersection of Interstate 95 and U.S. Route 1 near Massaponax. This postcard advertised "100 to 156 luxurious rooms. Color T.V., Music in all rooms, Olympic sized pools and restaurant, banquet and meeting rooms, playground equipment. Managed and operated by Chason Investments, Inc."

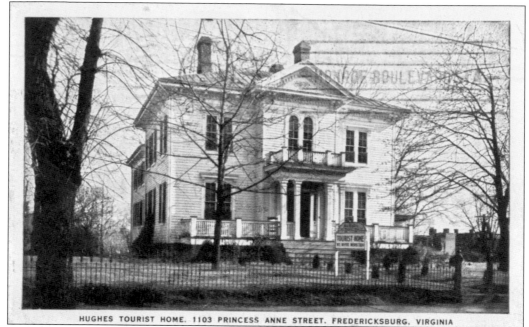

HUGHES TOURIST HOME. 1103 PRINCESS ANNE STREET. FREDERICKSBURG. VIRGINIA

HUGHES TOURIST HOME. Mrs. H. Lorraine Hughes was the hostess of this bed and breakfast–style inn, located at the corner of Princess Anne and Amelia Streets, which advertised "Comfortable Rooms with Running Water Automatic Heat and Innerspring Mattresses." The building is now used as law offices.

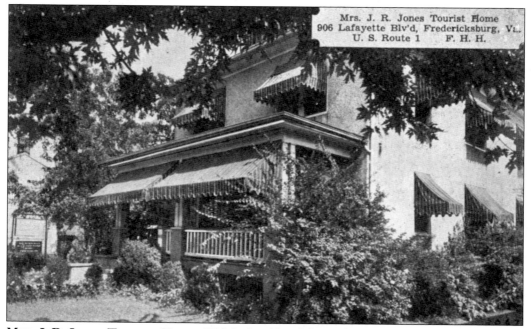

Mrs. J. R. Jones Tourist Home
906 Lafayette Blv'd, Fredericksburg, Va.
U. S. Route 1 F. H. H.

MRS. J. R. JONES TOURIST HOME. This bed and breakfast–style inn was located at 906 Lafayette Boulevard, Fredericksburg, Virginia (formerly U.S. Route 1 before the bypass was constructed).

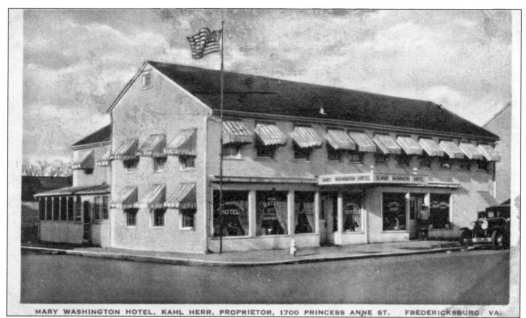

MARY WASHINGTON HOTEL, KAHL HERR, PROPRIETOR, 1700 PRINCESS ANNE ST. FREDERICKSBURG, VA.

MARY WASHINGTON HOTEL. This hotel advertised that it was "On the Washington–Richmond Highway. A delightful homelike Hotel. Excellent for tourists and commercial men. Good Dining Room and Cafeteria. Garages. Karl Herr, Proprietor." This structure still stands on Princess Anne Street, formerly the Washington-Richmond Highway, and is now part of the Fredericksburg Colonial Inn.

MARY WASHINGTON HOTEL LOBBY. The lobby of the Mary Washington Hotel was neat and comfortable looking. The mirrors and pictures were hung high on the walls; the overstuffed chairs, pedestal ashtrays, and the bentwood chairs add a vintage touch. Of particular interest is the turning postcard rack because many of the postcards used in this book would have been the same type displayed on it.

113

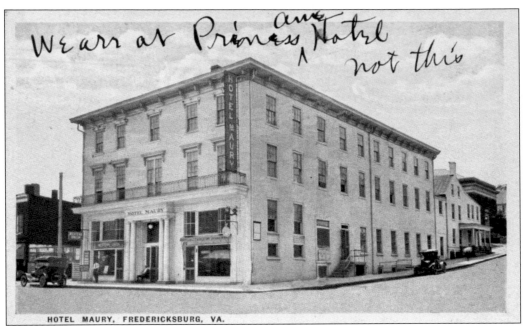

Handwritten on image: We arr at Princess and Hotel not this

HOTEL MAURY, FREDERICKSBURG, VA.

MAURY HOTEL. Built in 1837 and partly destroyed by fire in 1850, this building was used during the Civil War as a hospital. Maury Hotel, originally known as the Exchange Hotel, was the largest hotel in the city at the time. Its front entrance was originally on Caroline Street. A smaller hotel called the Eagle Hotel annexed at the rear of the building was removed. The entrance was moved to 202 Hanover Street, and the Caroline Street side was converted to shop fronts.

PAYNE'S MOTEL. Payne's Motel was also known as Payne's Motor Court. This postcard advertised: "New and completely modern with hot water heat, air conditioning and TV. Located in Virginia's most historical city. . . . Owned and Operated by Mr. and Mrs. W. T. Payne." Willie Payne was well known in the community and a prominent member of the Fredericksburg Rod and Gun Club. He was killed in an armed robbery at his motel. The building, located at 1904 Princess Anne Street, is used now as apartments.

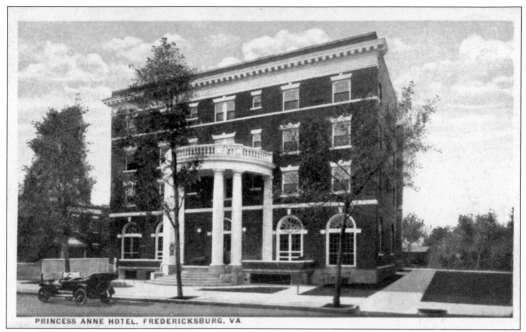

PRINCESS ANNE HOTEL, FREDERICKSBURG, VA.

PRINCESS ANNE HOTEL. This hotel was located at 904 Princess Anne Street and built on the site of Barton House in 1913. Winston Churchill and David Lloyd George visited the hotel, which, along with its restaurant, was considered one of the finest in the city. The Princess Anne Hotel was brick but later stuccoed to the appearance seen today. It is now called the Princess Anne Building and used as an office building. The postcard below shows the Princess Anne Hotel lobby.

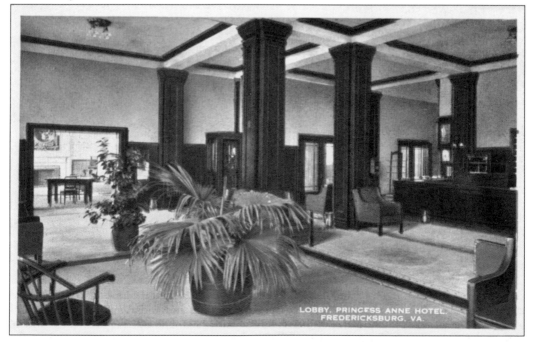

LOBBY, PRINCESS ANNE HOTEL, FREDERICKSBURG, VA.

PRINCESS ANNE HOTEL FARM, FREDERICKSBURG, VA.

THE TWO SPECIAL PRODUCTS FOR THE PRINCESS ANNE HOTEL

PRINCESS ANNE HOTEL FARM. This postcard shows two of the products used by the hotel to feed its guests. The card advertised, "The Hotel specializes in milk fed chickens and real Virginia hams, fresh eggs and vegetables from the farm daily." The hotel also offered a flower garden and pavilion. C. A. Abbey was named as president.

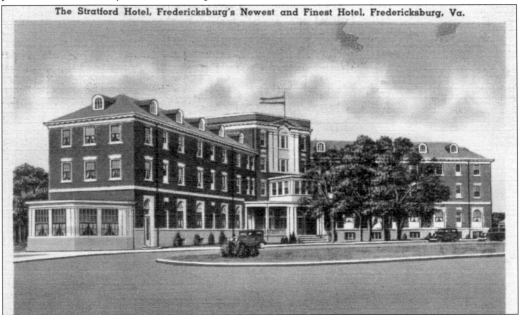

The Stratford Hotel, Fredericksburg's Newest and Finest Hotel. Fredericksburg, Va.

STRATFORD HOTEL. Samuel Washington, brother of George Washington, built his residence in Fredericksburg at this location. The residence was torn down to make way for the Stratford Hotel, which later became the General Washington Inn. It is now the General Washington Executive Center with offices and is located at 2215 or 2217 Princess Anne Street, which was once the Richmond Washington Highway.

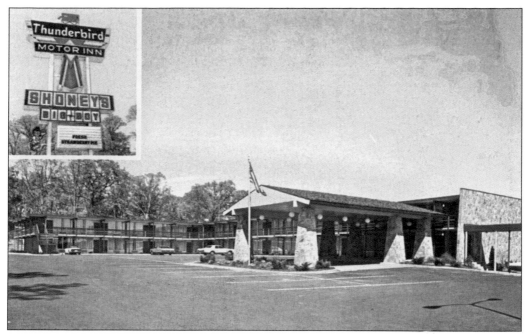

THUNDERBIRD MOTOR INN. This motel was located near the intersection of Route 3 at Interstate 95. This postcard advertised "108 beautifully appointed rooms, Color TV, AM FM Radio, Heated Swimming Pool & Shoney's Family Restaurant." It is now the Best Western Central Plaza Motel.

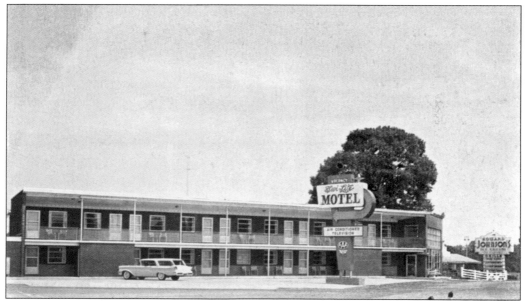

TWI-LITE MOTEL. This motel was located at 1209 Snowden Street just off U.S. Route 1 in Fredericksburg. The building stands in front of Park and Shop Shopping Center. This postcard advertised that it adjoined the Howard Johnson's Restaurant and was a "New, Modern Motel. 18 Luxuriously Furnished Rooms, Wall to Wall Carpets . . . Room Telephones. Television. Air Conditioned. Easily Accessible to Mary Washington College and Historical Points of Interest." The motel building is now used as apartments.

HOTEL WAKEFIELD,

HOTEL WAKEFIELD. This hotel, also known as the Wakefield Motor Hotel, was located at 1701 Princess Anne Street. On this postcard, it was advertised as being "Fredericksburg's newest hotel situated on the Richmond–Washington Highway (Route No. 1), within the northern city limits of Fredericksburg, convenient to residential and shopping districts and a few blocks

EDERICKSBURG, VIRGINIA

from the historical points of interest." The building that housed the Hotel Wakefield still stands on Princess Anne Street across from Hardees Restaurant and is now part of the Fredericksburg Colonial Inn together with several retail establishments.

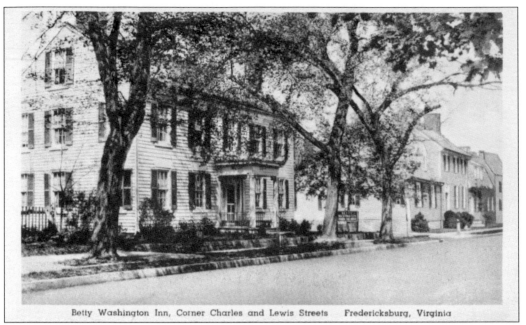

Betty Washington Inn, Corner Charles and Lewis Streets Fredericksburg, Virginia

THE BETTY WASHINGTON INN. This was a bed and breakfast–style inn at the corner of Charles and Lewis Streets. It was just across Lewis Street from the home of Mary Ball Washington. It was a favorite lodging for tourists because of its location and hospitality. It is now a private residence.

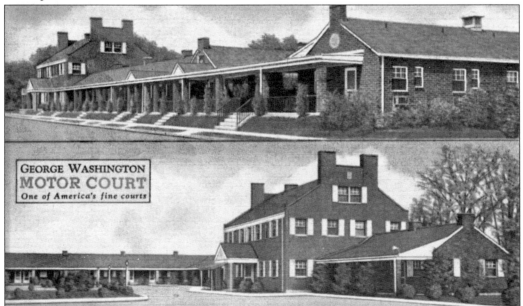

THE GEORGE WASHINGTON MOTOR COURT. This building is located on the U.S. 1 bypass in the city limits. This 1960s postcard advertised it as "'One of America's Finest Courts . . . two blocks South of Howard Johnson's Restaurant. 38 rooms with tiled baths, hot water heat, radios, air conditioned, fireproof. Built in 1949–52 . . . J. Lee Price, Owner." The hotel had 40 rooms when it was later owned by Herman B. Sarno and offered television and a swimming pool. It now houses offices and retail establishments.

Nine

STREETS

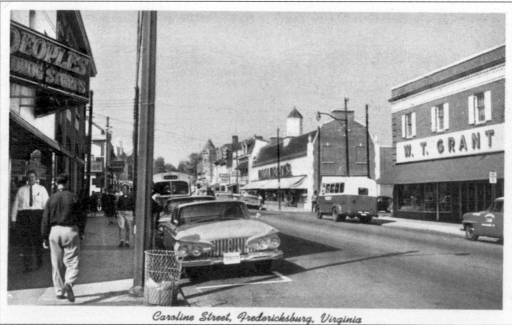

Caroline Street, Fredericksburg, Virginia

CAROLINE STREET. Caroline was the main street of Colonial Fredericksburg. Many taverns were located along it. Caroline Street was renamed Main Street, William was renamed Commerce Street, and Sophia Street was renamed Water Street, *c.* 1867. Today the Antique Court of Shoppes occupies the building that housed Woolworth's. Ben Franklin Crafts, at 925 Caroline Street, replaced W. T. Grant, which had replaced High's where you could get a large ice cream cone for 5¢ in the early 1940s.

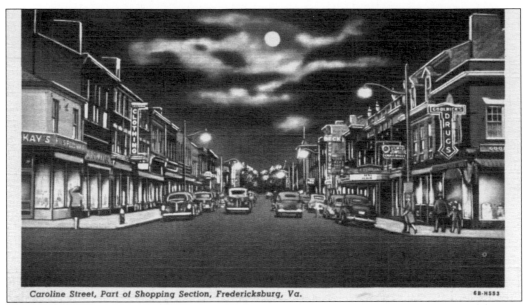

Caroline Street, Part of Shopping Section, Fredericksburg, Va.

CAROLINE STREET. Goolrick's Drug Store, located at 901 Caroline Street, is now Goolrick's Modern Pharmacy. Pres. George H. Bush made a campaign speech in 1992 in front of Goolrick's. This drugstore has the oldest continuously operated soda fountain in America. Ulman's Jewelry Store, located at 903, was owned by Simon Ulman, then by his brother, Jerome. It is now owned by Jerome's son, Jerry. The Colonial Theater, which became RC Theatres, was located at 907. Beck Furniture was located at 915 and E. C. Ninde Furniture was located at 917.

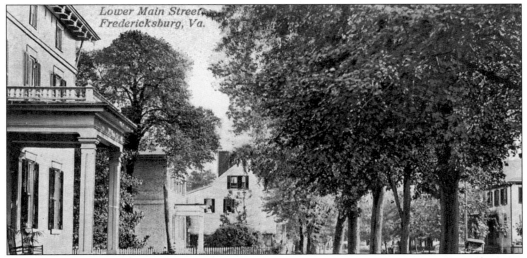

Lower Main Street, Fredericksburg, Va.

LOWER CAROLINE STREET. Lower Caroline Street was not part of Roger Dixon's original holding. It was developed later. Most of the houses in the area date to the early 20th century and are typical of the homes of craftsmen, tradesmen, and shopkeepers during the period from 1880 to 1920. Gen. George Weedon built his home at 133 Caroline Street, known as the Sentry Box. The house at 200 Caroline Street was used as a military school known as Phillips Academy in the late 1800s. John Goolrick, a prominent Fredericksburg educator, lived at 211 Caroline Street. James Monroe and his wife, Elizabeth, lived in his maternal uncle's home at 301 Caroline Street. Rocky Lane, an early through street leading to the river, is between the houses at 205 and 207 Caroline Street. (Bill Beck, Beck's Antiques.)

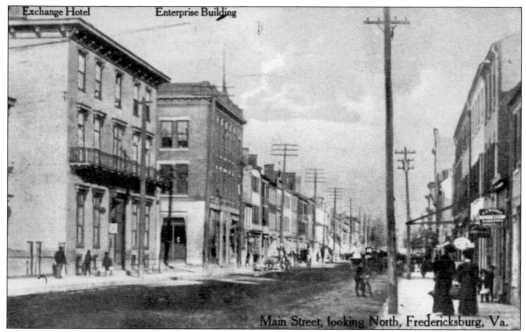

Main (Caroline) Street Looking North. The Exchange Hotel at left was renamed Maury Hotel. The Enterprise Building later housed the Athens Restaurant. Both building are on Caroline and Hanover Streets. The photograph used in this postcard was taken around the 1880s. The street had not been paved, and horse and buggies were the mode of transportation. The streets were paved with granite spalls (blocks) in the early 1900s. The blocks were later covered with macadam. In 1977, the blocks and macadam were removed and replaced with asphalt.

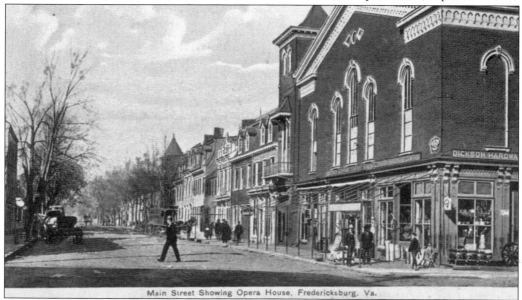

Main (Caroline) Street Showing the Opera House. This Opera House building, located at the corner of William and Caroline Streets, was torn down in the 1950s for a new, modern building that housed Woolworth's. Dickson Hardware operated from the ground floor of the Opera House.

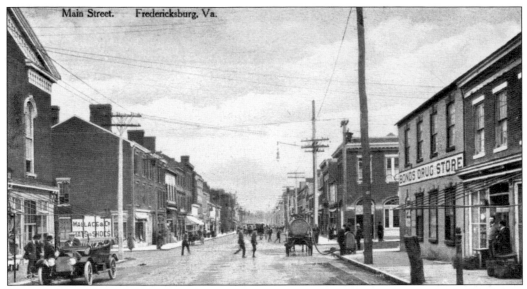

Main (Caroline) Street. Weedon's Tavern once stood on the northeast corner of Caroline and William Streets before it was destroyed by the 1807 fire that swept through Fredericksburg. From left to right, the Opera House, the Wallace and Company Store, and Bond's Drug Store are shown in this 1920s postcard. A High's Store and Scott's Hardware occupied the same building in the 1950s before it was razed for the more-modern structure that has housed W. T. Grant Store and now Ben Franklin Crafts Store. Crown Jewelers occupies the bank building today.

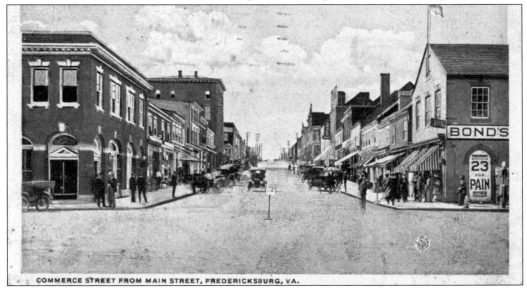

Commerce (William) Street from Main (Caroline) Street. Kishpaugh's Stationery was at 211 William Street. Today Crown Jewelers is at left, the Jewel Box at 208, Hunan Garden at 209, the New Orleans Café at 212, Cards and Cones Shop at 201 (in the Bond's Drug Store building), and Yamaha Music School and Burgess Barber shop at 207. Doggett and Scott grocery store had entrances at 205 Commerce (William) Street and 1002 Main (Caroline) Street. Hugh S. Doggett was a captain in the Confederate army during the Civil War and mayor of Fredericksburg from 1877 to 1880. Today the Caroline Street Café and Catering business operates from the same adjoined buildings.

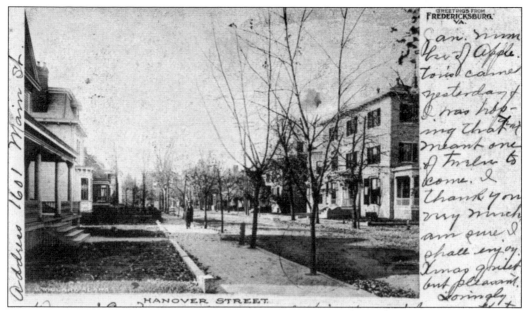

HANOVER STREET. This street was named for the German principality of Hanover, where George I, elector of Hanover, was selected as the most eligible Protestant to become king of England upon the death of Queen Anne in 1714. The Fredericksburg United Methodist Church, formerly known as the United Methodist Church, is at 308 Hanover Street and Federal Hill is located at 504 Hanover Street (see chapter six).

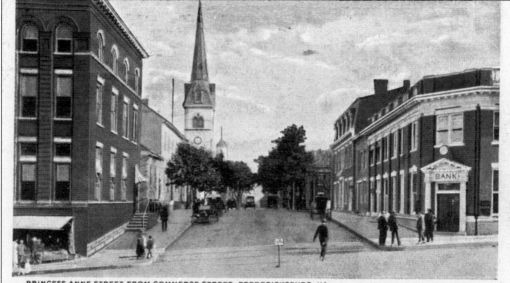

PRINCESS ANNE STREET FROM COMMERCE (WILLIAM) STREET. The Bradford building, which was located at the corner of William and Princess Anne Streets, was the tallest building in Fredericksburg with four stories and was known as Fredericksburg's only skyscraper. The Mayflower restaurant was located on the bottom floor. The Bradford building was destroyed by fire in 1963. The steeple in the background is the Fredericksburg Court House, built in 1852 and located in the 800 block. It was designed by James Renwick, who also designed the castle-style building of the Smithsonian Institution.

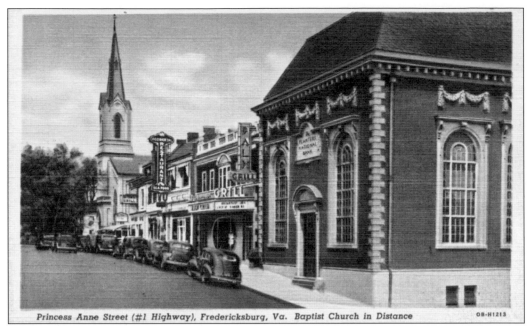

PRINCESS ANNE STREET, 1000 BLOCK. The Planters National Bank building, later Farmers and Merchants State Bank, located at 1001 Princess Anne Street, is now part of the Fredericksburg Area Museum and Cultural Center. The Palm's Restaurant was located at 1005, and Frederick's Restaurant is in there today. The Occidental Restaurant was located at 1009. Advantage Business Brokerage conducts business at 1011 today. The Southern Grill Restaurant was located at 1013–1017. Fredericksburg Baptist Church is at 1019.

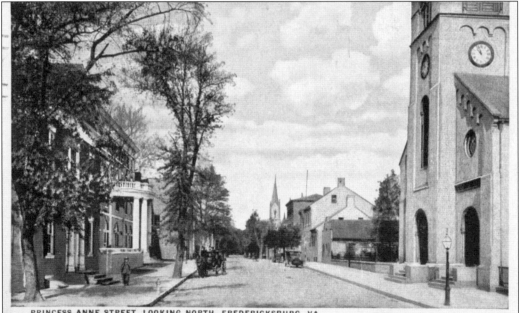

PRINCESS ANNE STREET, 900 BLOCK. Fredericksburg Area Museum and Cultural Center is located at 907 Princess Anne Street in the building formerly used for city hall. The present building was completed *c.* 1816. St. George's Episcopal Church is at 905 Princess Anne Street.

SOURCES

Alvey, Edward Jr. *The Fredericksburg Fire of 1807*. Fredericksburg, VA: Historic Fredericksburg Foundation, Inc., 1988.

———. *History of Mary Washington College 1908–1972*. Charlottesville, VA: University Press of Virginia, 1974.

———. *Ninety Years of Caring: Mary Washington Hospital, 1899–1989*. Virginia: The Mary Washington Hospital, 1989.

———. *The Streets of Fredericksburg*. Fredericksburg, VA: The Mary Washington College Foundation, Inc., 1978.

Carmichael, Virginia. *Porches and Portals of Old Fredericksburg*. Richmond, VA: Old Dominion Press, 1929.

Cropp, Barbara. *Journal of Fredericksburg History, Vol. 1*. Fredericksburg, VA: Historic Fredericksburg Foundation, 1996.

Darter, Oscar H. *Colonial Fredericksburg and Neighborhood in Perspective*. New York: Twayne Publishers, 1957.

Embrey, Alvin T. *History of Fredericksburg Virginia*. Richmond, VA: Old Dominion Press, 1937.

Felder, Paula S. *Fielding Lewis and the Washington Family*. United States: The American History Company, 1998.

The Free Lance-Star Newspaper. Virginia: 1990–2006.

Goolrick, John T. *Fredericksburg and the Cavalier Country*. Richmond, VA: Garrett and Massie, Inc., 1935.

Houston, Lemuel W. *A Bank for Fredericksburg*. Fredericksburg, VA: The National Bank of Fredericksburg, 1989.

Johnson, John Janney. *Hanover Street Revisited A Collection of Fredericksburg Vignettes*. Fredericksburg, VA: Fredericksburg United Methodist Church, 1989.

Quinn, S. J. *History of Fredericksburg, Virginia*. Richmond, VA: The Hermitage Press, Inc., 1908.

Shibley, Ronald E. *Historic Fredericksburg, A Pictorial History*. Fredericksburg, VA: Historic Fredericksburg Foundation, Inc., 1976.

Shibley, Ronald E. *Fredericksburg*. Fredericksburg, VA: Historic Fredericksburg Foundation, Inc., 1977.

Willis, Barbara Pratt, and Paula S. Felder. *Handbook of Historic Fredericksburg, Virginia*. Fredericksburg, VA: Historic Fredericksburg Foundation, Inc., 1993.

ACROSS AMERICA, PEOPLE ARE DISCOVERING SOMETHING WONDERFUL. *THEIR HERITAGE.*

Arcadia Publishing is the leading local history publisher in the United States. With more than 3,000 titles in print and hundreds of new titles released every year, Arcadia has extensive specialized experience chronicling the history of communities and celebrating America's hidden stories, bringing to life the people, places, and events from the past. To discover the history of other communities across the nation, please visit:

www.arcadiapublishing.com

Customized search tools allow you to find regional history books about the town where you grew up, the cities where your friends and family live, the town where your parents met, or even that retirement spot you've been dreaming about.